W9-ADG-832

CLASSICAL AFRICAN
SCULPTURE

by the same author

★

AFRICAN TAPESTRY
(Autobiographical)

★

AFRICAN DESIGN

★

AFRICAN ARTS AND CRAFTS

★

ART TEACHING IN AFRICAN SCHOOLS

★

With K. P. Wachsmann
TRIBAL CRAFTS OF UGANDA

★

With Hans Nevermann
AFRICAN AND OCEANIC ART

CLASSICAL AFRICAN SCULPTURE

by

MARGARET TROWELL

PRAEGER PUBLISHERS

NEW YORK · WASHINGTON

BOOKS THAT MATTER

First published in 1954
by Praeger Publishers, Inc.
111 Fourth Ave., New York, N.Y. 10003
Second edition 1964
Third, revised, edition 1970

New material © 1970 in London, England, by Margaret Trowell

Library of Congress Catalog Card Number: 76–120024

Printed in Great Britain

FOREWORD TO THE SECOND EDITION

Since this book was written ten years ago great changes have taken place in Africa so that both the map and place names throughout the text have had to be revised. Even now boundaries and titles may well be altered during the next decade making it impossible to keep absolutely up to date.

Apart from the alteration of place names two other matters have had to be taken into account in this new edition, both concerning the sculpture of Nigeria. Mr William Fagg through his study of the work of the royal craftsmen of the court of Benin has now interpreted the evolution of its various styles in a rather different sequence from that set out by Von Luschan many years ago, and his exegesis would seem to be the more satisfactory of the two. I have therefore followed it in my abbreviated account of Benin court art in place of the original section on pages 69–71.

Again in the first edition nothing was said of the ancient Nok culture of which fragments had begun to come to light in the spoil heaps of the tin mines of northern Nigeria. Now, due to the field work of Mr Bernard Fagg, it is clear that this type of sculpture, so named after the mining township where the first specimens were found, spreads across a vast area from the Kaduna River to Katsina Ala, south-east of the Benue River, and is the earliest yet to be discovered in Africa as it has been dated by geological and radiological methods to a period from about 500 B.C. to A.D. 200.

The fragments found are of figures varying from a few inches high to over life size, those of limbs and bodies seem to be very roughly worked out in comparison with the heads which have been found. The latter are usually strongly stylized, although following a large variety of different conventions, but having certain traits which unify them all, such as the piercing of the pupils of the eyes and the nasal and aural orifices, and the strongly defined eye borders which are usually tri- angular or semi-circular. This concentration upon the carving of the

head rather than on working up the whole figure equally, and also the emphasis laid on its importance by the alteration of its proportion to a quarter instead of the naturalistic one sixth or one seventh of the total height of the figure, is strongly characteristic of a great deal of the finest African sculpture. (PLATE XII.) Many other sculptural remains may well be awaiting discovery under the soil of Africa, and we may hope yet to find the bridge spanning the gap of a thousand years between the cultures of Nok and Ife.

FOREWORD TO THE THIRD EDITION

Classical African Sculpture originally came into being as a series of lectures written towards the end of the last war for students of the embryo Makerere College, Uganda; its purpose being to awaken in them an interest in the study of African culture. At the time no comprehensive English books on African art were available, and the few German and French tomes on the subject were ponderous and would have been beyond the comprehension of African students of that generation even if translated.

A few years later, owing to a visit of Geoffrey Faber to Uganda, the author was encouraged to apply for a University Research Grant to study the collections of the British Museum, the Musée de l'Homme and the then Musée Royal du Congo Belge, now the Musée Royal de l'Afrique Centrale. In the ensuing book the tribes were set out in a sequence running quite contrary to the order now universally accepted; this detracts very considerably from its value today as a book of easy reference. In this third edition the fault has therefore been rectified, but apart from this the text remains virtually the same.

CONTENTS

ILLUSTRATIONS

PLATES
(at end of the book)

9

ILLUSTRATIONS

MAPS

ACKNOWLEDGEMENTS

Thanks are due to all authors and their publishers whose works are quoted in the following pages; and more especially to Professor Talbot Rice whose analysis of the observer's reactions to a work of art is quoted extensively in the first section: to Professor Griaule whose suggestion that certain types of art are directed towards a spiritual rather than a human audience was the starting point for the train of thought followed out in the second: and to Mr Leon Underwood whose clear and well-defined statement on the difference between the intellectual vision of the work of Ife and the more emotional approach of other African 'schools' contributed to the development of the idea of man-regarding art.

For the illustrations most grateful thanks must be paid to the directors and staffs of the museums, and to the private collectors, whose names appear on the appropriate plates.

For personal help and encouragement without which neither the study nor the writing of the book might have been brought to a conclusion the author is in debt to Dr Gervase Mathew of Balliol College, Oxford; to Dr Audrey Richards, of the East African Institute of Social Research; to Mr William Fagg of the British Museum; to Professor Olbrechts of the Musée Royal du Congo Belge; to Dr Klaus Wachsmann of the Uganda Museum; and above all to her husband. Valuable practical help and criticism of the first draft was given by Mrs Goldthorpe and Mr A. J. Sifton.

Finally the study of the subject was made possible by a research grant from the Makerere College Council which is acknowledged with gratitude.

THE SCHOOL OF ART, MAKERERE COLLEGE K. M. T.

December, 1953

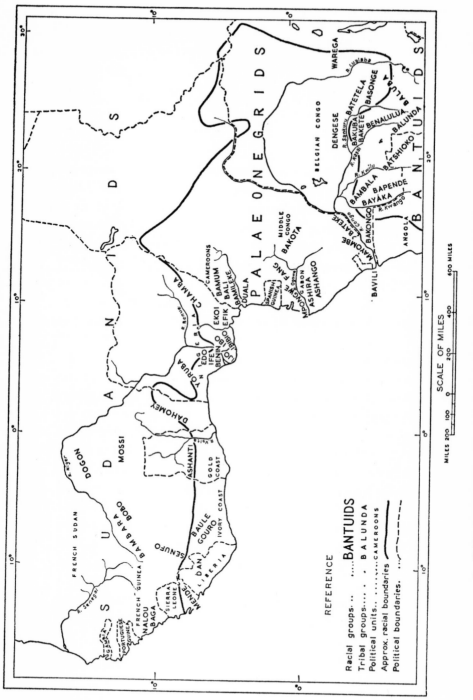

I. MAP SHOWING STYLISTIC REGIONS OR 'SCHOOLS' OF TRIBAL ART

REFERENCE

Racial groups...**BANTUIDS**
Tribal groups.... . . BALUNDA
Political units...... BAKONGO
Approx. racial boundaries.
Political boundaries. ...

SCALE OF MILES

MILES 200 100 0 200 400 600 MILES

2. VEGETATION: the social background, and therefore the type of work demanded from the artist, has been largely formed by geographical conditions which have also controlled the materials obtainable for his carving.

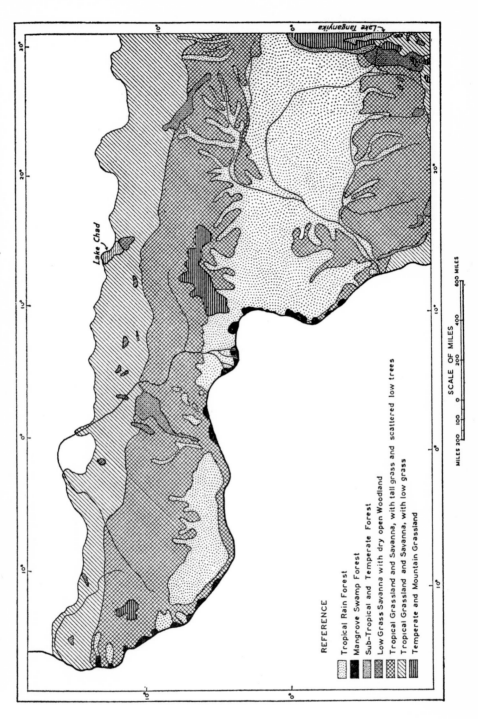

REFERENCE

Tropical Rain Forest
Mangrove Swamp Forest
Sub-Tropical and Temperate Forest
Low Grass Savanna with dry open Woodland
Tropical Grassland and Savanna, with tall grass and scattered low trees
Tropical Grassland and Savanna, with low grass
Temperate and Mountain Grassland

SCALE OF MILES

MILES 200 100 0 200 400 600 MILES

Lake Chad

Lake Tanganyika

I

THE APPRECIATION OF AFRICAN ART

It is generally accepted today that what may be termed 'classical' African art is a great art, worthy of a place among the other great arts of the world; yet it is not easy to study it, for neither actual material nor comprehensive books on the subject are easily accessible to the student.

It is singularly unfortunate for the African that this is so, for it robs him of a genuine reason for racial pride. His classical art may have been connected with a magico-religious culture which he is rapidly out-growing, and so in its actual form must be regarded as a dead or dying art; yet we do not judge either Greek or Egyptian art by the validity of the religious beliefs which were their inspiration and we should be able to approach African art in the same unprejudiced manner, appreci-ate its essential qualities, and hope that these qualities will carry over into the art forms of the new African world.

Little is left of the art of any 'early' civilization beyond that which was carried out in stone; and the art of Africa, although continuing in its 'early' stage until comparatively recent times, has suffered the same fate. The great exception is the discovery made by Bernard Fagg over the last twenty years of the important Nok culture stretching across Northern Nigeria which was brought to light when specimens consist-ing of fragments of large and small terra-cotta figures were found in the spoil heaps of European-owned tin-mines. The African seems rarely to have worked in stone and metal, and the tropical climate with its heat and, in many regions, excessive humidity, together with the insect pests which thrive in such conditions, made it impossible for carving in even the hardest timber to survive for long. The African him-self did not regard its preservation as of any aesthetic or historic value; a mask or carving would receive great religious veneration in its time, but when the day came that it rotted away or was eaten by white ants, a fresh piece could be carved and consecrated with the correct observ-

ances, so that the spirit might enter in. Later, when contact with western belief or unbelief caused him to despise his old ways of life, the mask or ancestor carving could only be regarded as an unfortunate reminder of his 'primitive' past; and if not actually destroyed, hidden away in some grove or cranny where it would soon disintegrate.

So it is rare today to find many wood carvings of any antiquity in Africa itself, and for serious study we must look to the museums of Europe and America rather than search for them in their native continent. Even here we are at a sad disadvantage, for the early explorers, slavers, traders, missionaries, sailors, and members of punitive expeditions who visited the country, could not regard with any respect the idols of the primitive peoples with whom they dealt; all they could be expected to do was to collect curios to amuse themselves and their friends, and many of the earliest and finest pieces in our museums have drifted in, quite undocumented, through gifts and junk-shop purchases from such casual collections. It was not until well into the present century that, on the one hand, scientific expeditions began to collect material with careful ethnographical data, and on the other, the art critics and collectors began to realize the aesthetic value of the pieces which found their way into the curio shop or sale-room. The two approaches were for the most part kept separate, the trained scientist being purely interested in the ethnographical significance of each object, and having little discretion where artistic values were concerned; the art collector concerning himself not at all with the living background from which the piece had come and so missing much of its imaginative appeal. The final disaster was reached in the second world war when many museums lost both actual collections and also all data of what remained, when their files and card indexes went through bomb damage and fire. Liverpool museum is perhaps the saddest example in Britain, for its very fine collection of negro sculpture suffered badly, and little information could be found as to the provenance or age of the many good specimens which have been preserved.

The unsatisfactory state of the actual collections of negro sculpture was reflected in the literature available. England lagged behind in study and appreciation, although a certain number of invaluable and well-illustrated books were produced in French and German. During the last ten to fifteen years, however, an increasing number of excellent books have been written in England, the United States and on the Continent. In these not only has the ethnological approach been more

scholarly but the techniques of the craftsmen has been studied, and the aesthetic value of the works fully appreciated.

Is it possible, in fact, to produce a comprehensive study; for what would such a work involve? We have seen already that many of the best specimens in the museum collections are completely or partially undocumented; they may be labelled 'Ivory Coast', 'Nigeria', or even more vaguely 'West Africa', but their actual provenance is unknown. When we attempt to build up our knowledge of the ethnography of these districts, we again meet confusion and lacunae, for few definite and authoritative conclusions have been reached concerning the early history and racial grouping of their inhabitants.

Again, our specimens may be labelled 'fetish object', 'mask used in ritual dances', or 'sacred stool'; what information can we glean concerning the philosophy and ritual of which these are an expression? Can our imagination take these static, long-dead objects and place them again in all the colour and movement, mystery and awe, with which they were once surrounded?

These considerations might seem, however, to be secondary for the student of art; they will certainly have to be considered in time, but our first approach should be the aesthetic one. As we glance through the accompanying illustrations, or even better, handle actual pieces of carving in the collections, we become deeply impressed with certain qualities which cause us to rank African art amongst the world's masterpieces. In all we find a tremendous sincerity and forcefulness, and also an unconscious realization of the form demanded by the material and technique which is used. In some robust vigour is the key-note; in others we find a delicacy and sensitivity which superficially might be considered astounding among a primitive people. Again, we are impressed by the highly stylized sense of design in the work from one area, and contrast it with an equally strong naturalism from another. Quite obviously we can evaluate this art by the criteria of line, form and content, appropriate to the study of the art of any culture.

Our first impulse, then, will be to type the various works into 'schools' according to their characteristics, and make some attempt to assess their formal qualities by universal standards. In this classification we shall be assisted by the conservatism of the African craftsman, who made little attempt to depart from the accepted formula of his district; the African artist had not reached the stage of individualism; in one case only — that of 'The Master of Buli' of the Baluba — and possibly also in the carver

or one or two of the portrait statues of the Bakuba Kings, do we trace the signs of one outstanding master; the rest dwell in the obscurity of the primitive or mediaeval craftsman.

Yet the very clarity of definition of the various 'schools' and styles which we find leads us at once to realize that the aesthetic approach is not enough; for although the more training and experience we have had in the appreciation of art the more readily we delight in pure form, yet we realize this visual appreciation must be supplemented by our intellect and our emotion. Our intellect is continually demanding an explanation of why art has developed its particular idiom in these different areas, and our emotion demands to be left into the secret of the psychological reactions of the creators of these works of art, and those of the audience for whom they were made.

Professor Talbot Rice[1] gives a very clear account of this compound reaction of the observer to a work of art as follows:

'The effect which a work of art exercises on the observer is, in the author's opinion, two-fold; it is both sensed and realized. The degree in which these two emotions are experienced varies with every observer, some relying much more on intuition, others preferring to analyze their emotions consciously. But in every case the two sensations must be present, if that which the very word art implies is in question at all.

'The sensation is something that we experience on first seeing the work, and the emotion may well be both spontaneous and considerable. It is something that is communicated to us by the thing observed, be it work of art, like a picture or piece of sculpture, or work of nature like a landscape. It comes like a current of electricity in the atmosphere, so that the nature of the work itself and anything that we may know about its context have no part to play in creating the emotion that we feel. As Picasso said, the artist's business is to produce the work, and the observer's is either to be bowled over or not bowled over by it. The emotion radiates from it, and it is to be sensed by the educated and uneducated alike, though the degree of the delicacy of our artistic sensibilities, which is unquestionably usually more developed in the educated, becomes more and more subtle in proportion to the degree of the nervous development in the person concerned.

'The second, or realized, emotion is something quite distinct, which usually comes afterwards, and which depends almost entirely upon our knowledge of the work under consideration or of its context. It may be a

[1] D. Talbot Rice, *The Background of Art*, London, 1939, pp. 16 et seq.

knowledge of, and familiarity with, pictures as a whole, which enables us to analyze and understand some particular picture more fully; it may be a knowledge of the period in which a certain work was produced, which enables us to set it in its true perspective, or to regard it as the mirror of the society by which and for which it was produced; it may be a familiarity with some particular artist's work, which enables us to look at his pictures with an idea of his aims and sympathies clear before us; it may be an understanding of some particular craft, which makes it possible for us to appreciate the manner in which technical difficulties have been overcome. It may, in fact, take upon itself all sorts of forms and may add very greatly to our powers of appreciation, though it remains, this realized understanding, something that is quite apart and distinct from the primary sensation, for it has to do in the main with associated values, and not with feelings of emotion which are of a purely aesthetic nature.'

And again:[1]

'The full and complete study of man's artistic products does thus not resolve itself into a task of learning the nature of certain styles, either of an individual artist or of a group, or even of a nation or an age. It is not to be satisfied only with an examination or analysis of artistic products, with the quality of form and composition, or the relative aesthetic quality of the object in mind. It would not even be enough to penetrate to the basis of the causes of aesthetic emotion and to be able to explain these causes to others, for, as we have already stressed, aesthetic emotions are in the main our own concerns, which are perhaps to be directed, but certainly not to be entirely regulated from outside. In reality the essentials of art study are more fundamental, and necessitate a thorough understanding of man's nature, physical and spiritual; of his modes of expression, visual and otherwise; of his reactions to surroundings; of his relationships with the world, in each and all of its various aspects; and of the progress of all these factors through time.'

We cannot in fact filter out the purely formal aesthetic values in appraising a work of art, for the artist (unless he be the modern intellectual) has never striven himself to work in that way. The modern sculptor seeking to free himself from the associated religious, patriotic, or erotic values which he felt dominated Romantic and Greek sculpture, set himself to produce works in which the essential character was the creation of formal meaning and in which no other meaning was neces-

[1] Ibid., p. 67.

sary. In so doing he rendered tremendous service by clearing away sentimental accretions so that we might enjoy formal values for their own sake. In his study he turned to primitive sculpture and Egyptian sculpture, for here he saw formal values clearly expressed with apparently no conflict with associated values. But it would be utterly false to infer from this that Egyptian sculpture had no associated values for the Egyptian, simply because the expression of the philosophical values of permanence and power does not obviously conflict with our formal values of form and mass; or that the associated value of correct ritualistic formula does not exist for the primitive artist because to our ignorant minds it is not apparent. For full realization and understanding then of any work of art we must attempt to have some understanding of the total purpose of its creator.

This is indeed a formidable proposition when we realize how comparatively little is known of the history and social background of the people whose works we shall be studying, and how dangerous it is to generalize from any knowledge which may be available of one particular group or tribe; nor can we hope to find it easy to enter in through sympathetic imagination; for whether we be European or modern educated African we dwell in a world of thought poles apart from that of the African for whom these works were originally created. Nevertheless we must in our study build up some sort of a background which will aid us to develop this realized reaction, and this can be done to some degree from the little information available.

It must be very strongly stressed that any attempt to assess the kind and quality of works of art of each area which we are considering is dependent on the specimens which have so far been collected, and that there may be many lacunae which, if filled, would completely change our judgement.

Equally our interpretation of the social background which has resulted in these works of art is dependent on the literature available. Even if the information at hand is always correct, and this is often a point on which it is not easy to decide, different sources will emphasize different aspects and more information will be available concerning one area than another, so that it becomes almost impossible to give a balanced account of the whole.

We can study what little is known or guessed of the long story of migrations across Africa from the east; of early contact with the Mediterranean civilizations by land and sea; and of later contact with Euro-

pean and Moslem influences. We can follow traces of the build-up of the great negro kingdoms in mediaeval times. We can note the type of country from which the various works come, and consider the probable effect of geographical and physical conditions on the life of the people; we shall find that the system of life which is possible in open savannah country is very different from that which is lived in dense forest land, and that this affects both social custom and religious belief.

We shall have to attempt to understand this social and religious background by the exercise of our imagination so that we may enter into the inner significance of African classical art, which is in almost every case a part of the appurtenances of ritual. If, for us, the mask or ancestor figure is no more than a dead carving in a museum case, we can have no sense of its effect upon the observer who knows of all the ritual which has gone to its making; of the spirits which have had to be propitiated, and of the life-force which it now contains which watches or takes part in the dance of which it is an accessory, and which will benefit together with the family or other members of the society from the successful carrying-out of liturgy and movement.

This sense of background will not perhaps be so difficult for us after all, for the need for colour, rhythm, and ritual is fundamental to every man.

'Rhythm is a constraint; it produces an unconquerable desire to yield, to join in; not only the step of the foot, but also the soul itself follows the measure — probably the souls of the gods also, as people thought. . . . Looked at and investigated as a whole, was there anything *more serviceable* to the ancient superstitious species of human being than rhythm? People could do anything with it: they could make labour go on magically; they could compel a god to appear, to be near at hand, and to listen to them; they could arrange the future for themselves according to their will; they could unburden the soul of any kind of excess (of anxiety, of mania, of sympathy, of revenge), and not only their own soul, but the soul of the most evil spirits — without verse a person was nothing, by means of verse a person became almost a god. Such a fundamental feeling no longer allows itself to be fully eradicated, and even now, after millenniums of long labour in combating such superstition, the wisest of us occasionally becomes the fool of rhythm, be it only that one *perceives* a thought to be *truer* when it has a metrical form and approaches with a divine hopping.'[1]

[1] Nietzsche, *Works*, edited Levy, Foulis, pp. 117–19.

In planning the necessary approach for our realized reaction to African art we are at once struck by the complexity of styles which we find. We see art which is completely abstract, and from this we can pass through all stages of stylization, until we reach the completely naturalistic. We find carvings which are so simple that they appear to be tree trunks with only slight suggestions of human form, and alongside these we may put others which are an arabesque of design or an architectural composition consisting of many figures. We find work which is completely static, and on the other hand pieces which show a lively sense of movement.

In the bronze and terra cotta heads of Ife we find an intellectual grasp of mensuration which is classical in the Greek sense; while in the greater part of African sculpture the emphasis is on subjective expression and the resultant art may be termed romantic and emotional.

How can we explain all this? Does the answer lie along ethnological, historical or geographical grounds? Doubtless it does to a very great extent, but when we attempt to classify the work along these lines we straightway become lost in sheer speculation. So little is known of the past and the experts differ so greatly in their theories, that they cannot at this stage help us much in our particular field. Apart from the fact that classification of works of art, according to racial or tribal divisions alone, at once places us in difficulties when we find one style carrying across from one racial group to another, and on the other hand small compact tribal areas showing more than one art form; we should on these terms of reference be bound to consider the sculpture of every group with equal care and put on one side all aesthetic criteria.

If on the other hand we decide to discuss our subject along purely aesthetic lines, completely ignoring its social background, we lose much of its significance and are liable to make statements which do not ring true in the ears of those who know anything of African thought and custom.

It is clear that we must make use of both approaches and find some method of integration, if we are to produce a balanced study of the matter.

If neither classification of art according to the ethnological grouping of its makers, nor according to formal values alone, will suit our purpose, we must yet attempt to split up our subject into some manageable system. The most obvious division might be between religious and secular art, but the spiritual cannot be separated from the secular in African philo-

sophy, for the departed still take an active part in tribal life, and the unseen world is active all around us. Neither is it possible to classify work as pure or applied art; for in some cases the religious statue would have for its owner a more functional value than the carved stool or decorated textile.

There is one line of approach, which would appear most comprehensive and elastic, yet sufficiently clear to guide our thought; permitting us to use ethnological and sociological data in so far as they really contribute to our understanding and yet to concentrate on formal values. It is to divide the work which we are studying according to the audience for which it was first produced. Working along these lines we have three main divisions — Spirit-regarding Art, Man-regarding Art, and the Art of Ritual Display.

Spirit-regarding Art is addressed chiefly to spiritual forces, and is not concerned with attracting or pleasing a human audience; its object is to harness spiritual power for the assistance of living members of the tribe.

Man-regarding Art has often a more secular significance. It serves a living patron, supports his social prestige, and often consists in luxury articles which are the perquisites of caste. On a different level it may be more bourgeois in its form, being made to delight the common people, who also have a desire for such productions.

The Art of Ritual Display falls between the two, being the active link between the eternal and the temporal, Spirit-regarding in its ritual preparation and use, Man-regarding in its decorative or expressive qualities.

This approach cannot be made the basis of any hard and fast classification of the works which we are studying, for the social and psychological background of the African is, like that of any other people, too complex for any such facile division. An ancestor figure may be produced and used by a tribe in which the sophisticating effect of aristocratic patronage is strong; in such a case the appearance of the statue will defy rigid classification. In another case the purpose of the statue cannot be sufficiently clearly defined from ethnological data for any arbitrary classification to be honest. We may term a carving 'Man-regarding' because it shows those stylistic qualities which we believe are the results of aristocratic patronage; yet its immediate purpose may be the ritual service of the royal ancestors. All these aspects — Spirit-regarding, Man-regarding, and Ritual Display — are but strands in the yarn, strands which cannot be completely unravelled.

Nevertheless detailed consideration of the formal style which we might

expect to find in sculpture, according to the audience or purpose for which it was created, is a legitimate and essential part of art study. Moreover it is extraordinarily instructive to note how closely such criteria fit in with what is known of the social structure and religious outlook of the people whose work is under consideration.

When all this has been done, however, we are still left with the imponderable qualities of the individual artist or of the community for which he speaks. The style of the work may be largely conditioned by the purpose for which it is made, yet within one framework we shall find completely different forms of expression. In Gabon, for instance, both the Fang and the Bakota carve figures which are known as Guardians of the Bones. These are placed above baskets containing the bones of the ancestors in order to scare off intruders. The Fang guardians are very beautiful and sensitive carvings of slightly stylized heads; while those of the Bakota are figures practically reduced to abstracts; striking expressions of formal design. Neither the early travellers, nor the ethnologists, seem able to give us any guidance as to why these two tribes should use such entirely different forms of expression; and the Fang, whom from their carved heads we should expect to be a people devoted to the life of gentle contemplation, appear from all accounts to have been an outstandingly energetic tribe, always on the march, and conquering all that lay before them.

Again the Basonge and the Batshioko have both been strongly influenced and dominated by the Baluba; but whereas the best of Baluba sculpture is outstanding for its gentle sensitivity, the best of both Basonge and Batshioko work is equally outstanding for its ruthless force.

I know of no reason which will explain why Baule carvings express their creators' delight through fine finish and subtle form, while those of the Cameroons express an equal joy in life through a kind of coarse unfastidious robustness; nor do I understand why, quite contrary to the custom of most tribal artists, who follow the unvaried formulae set by local tradition throughout their work, the Dan-Ngere tribes produce such a wide variety of masks ranging from the most naturalistic to the extreme abstract. These things can never be adequately explained; they may only be enjoyed.

II

THE FUNCTION OF
THE CRAFTSMAN AND HIS ART

SPIRIT-REGARDING ART

We have defined Spirit-regarding Art as an art which is addressed chiefly to spiritual forces with the object of harnessing spiritual power for the assistance of living members of the tribe. Strictly speaking, all objects used in ritual display should be included in this category, but for the sake of simplification we will limit our discussion to figure carvings which have this significance at all times and not chiefly during ritual ceremonies. These figures all aim at attracting and holding spiritual powers, and both maker and owner will make every effort to this end. Herskovits[1] states that many householders among the Dahomey prefer to carve their own figures rather than to entrust the work to a professional carver, for they fear that the carver, by accident or design, may allow some malignant force to enter. If this is so, the lack of skill of the amateur carver may be a contributory factor to the very simple stylization which we believe is typical of Spirit-regarding Art.

The carver will strive, both through his own action, and, where necessary, in conjunction with the priest, to use the correct materials, to perform the necessary rituals and to repeat the right formulas at each stage of his enterprise; so that at no point will spiritual forces of any kind be antagonized and the final carving will be acceptable to the desired spirit. It will follow that the work will be conservative and unchanging, modelling itself on previous examples which have appeared to fulfil the conditions desired by the spirits and avoiding any originality which might be dangerous (PLATE I). Ritual technique in the making will be more important than appearance. From the start rites must be performed

[1] M. Herskovits, *Dahomey*, 2 vols., Augustin, New York, 1938, Vol. II, p. 365.

over the tools to be used, with prayers for assistance against accidents. Then the spirits which dwell within the trees needed for carving must be propitiated. Griaule[1] says, 'The cutting down of a tree . . . is not merely a technical action. The tree contains forces which will not be dispossessed without a struggle. It contains its own force, like all living things, and often that of a spirit which has chosen it as a habitat as well. Moreover, as the bush is the home of powers who are worshipped by a definite cult, it is important to pay them in some way for the tree which is going to be removed. The dangerous forces, set in motion when it is cut down, are appeased by different practices which are of two kinds; one consists in removing them by prayer or offering them compensation; the other in using a force taken from elsewhere, which when introduced into the tree will keep in check the one which lived there before.' During the carving other rites will be performed, both for the tree and other materials such as colouring matter.

More important than the recognition of the carver's ritualistic approach to his materials and his handling of them is an appreciation of his whole conception of the unity of the spiritual and the physical world. For this we must put on one side our western picture of each and every individual as a unique personal being encased within the shell of his own body, influenced only to a limited degree by communication with other unique personalities; and replace it by the concept of selfhood spilling out into the world beyond the confines of the experiencing body and echoing back again from other selves. This sense of a fluid spiritual force coursing through mankind was limited only by the Africans' knowledge of the outer world. Where travel and communication were difficult it was virtually confined to the family, clan, and tribe, together with neighbouring tribal enemies whose spirits were greatly to be feared. Both the living and the dead were literally one people, and the individual was only one small fragment of the fluctuating life of the tribe.

Indeed this sense of oneness, of participation in the spirit, went even beyond the boundary of mankind. It included participation in the whole visible and invisible universe; the dead were still an intrinsic and powerful part of the family, indeed in matters of the spirit they were more powerful than the living themselves. Furthermore, not only the living and the dead but also other forms of existence, the very rocks and stones, in fact the whole cosmos, were included in the Africans' conception of this unified totality which they sought to participate in and

[1] M. Griaule, *Arts of the African Native*, London, 1950 ;p. 78

to apprehend. The visible and invisible world, the human and divine, the past and present, formed one harmonious whole and man had to fit himself into this unity. Taboos must not be violated, rites of passage and other rituals must be observed, spirits must be appeased, and above all the power life force, or mana, must be enticed, placated and harnessed for the well being of the tribe or smaller groups within it. The greater part of African sculpture and mask-making is connected with this necessity. The works are carved not as representations of the spirits to please or interest a human audience, but as objects within which the spirit may dwell.

Amongst the Dogon, according to Griaule,[1] after death the soul eventually goes on its way into the world of shades, but the vital force must be collected and constrained, partly because its freedom would be of the utmost danger to the rest of mankind, and partly because it is a power which must be re-employed within some other member of the group.

Hardy,[2] on the other hand, would suggest that the personal soul, quick to take vengeance on the smallest slight, amenable to flattery and gifts, is in charge of each man's share of vital force. On death the harmless vital force passes on into some other life, while the personal soul waits in the shades ready to harm or help the living according to the treatment meted out to it. This belief in a vital force is common among many African tribes of the Western Sudan and the Congo. Parrinder[3] quotes it among the Fon as 'The God who lives in everybody's body' and 'the Over-soul, a portion of God', ideas prevalent among the beliefs of the Ibo and Bantu tribes of Nigeria. Talbot[4] also speaks of the belief of the tribes of Nigeria in an 'Oversoul', 'a kind of group-self, able to manifest itself in several individualities at the same moment,' and like Griaule suggests a very close resemblance between this type of belief and that of the early Egyptians.

In his most interesting book, *Arts of the African Native*, Griaule would emphasize the necessity, according to the Dogon of the Western Sudan at least, of capturing the vital force at death and anchoring it firmly within some concrete form. In support of his thesis he recounts a Dogon myth which would seem to be an excellent exegesis of the idea of the ancestor figure and also of the mask and other accessories of the dance which we shall consider in the Art of Ritual Display. The myth

[1] Griaule, *Arts of the African Native*, p. 69.
[2] G. Hardy, *L' Art Negre*, Laurens, Paris, 1927, p. 21.
[3] G. Parrinder, *West African Religion*, Epworth Press, London, 1949, p.122.
[4] P. A. Talbot, *The Peoples of Southern Nigeria*, Oxford, 4 vols., pp. 277 et seq.

tells of the first use of costume in ceremonial dance and display by the spirits who inhabited the earth long ago, and how the appurtenances were stolen and copied first by the early 'red' people and later by invading 'black' folk.

It tells how through a certain incident the spirit of an old chief was polluted by contact with the magic fibre cloak so that it could neither go into the next world nor return to this, and how through this incident death came into the world. After various occurrences man learned to carve figures and masks and so to consecrate them that they became safe anchorages or depositories for the vital force of the departed, thus to some extent protecting men from their ill-will.

Just how far the ideas behind the Dogon legend would be valid for the neighbouring tribes is a matter which cannot be discussed here, but the story does make a very valuable contribution to our understanding of the atmosphere in which certain forms of African art are created and used. The idea of the letting loose upon the world of spiritual powers which occurs at every human or animal death is the central point of the story.

In using this myth as his exegesis of the importance attached to ritual in the construction and use of ancestor figures Griaule points out that the carvings were never intended either to attract or terrify a human audience. They were to be kept hidden within the sanctuary, seen only by the priest or the head of the family, against a religious background inaccessible to the common man. So, in the area of which he writes we should see Spirit-regarding Art in its purest form unaffected by the desire for human applause; and indeed it appears to be so, for the figure-carving of the Western Sudan area has just those qualities of simplicity, and static stylization, of avoidance of originality and of conservatism which we should expect; in areas where other qualities such as a realization of anatomical form, expressiveness, decoration, and movement creep in, we find a more strongly Man-regarding Art existing alongside.

These carvings of the ancestors have most clearly, according to the anthropologists, the function of housing the soul or the vital force of the departed. There are other types of magico-religious figure-carving the function of which is not so clearly defined. As the ancestors are considered to be concerned with the fertility of the tribe and its herds and crops, some of the figures which are accredited to them are obviously symbols of the principles of generation.

There are many figures connected with special cults, such as those of

Eshu or Legba of the Ewe and Yoruba, or the twin cults of the same tribes. Again there are the personal protectors of the master of the house, such as the *Ikenga* figures of the Ibo. Then come the guardians of the village or of the house, represented by figures placed at the door and facing outwards; these are probably not considered as dwelling-places of the spirits, but merely as receptacles to absorb and draw away evil. It is possible that many undifferentiated little figures belong to this category. Few of them are of great artistic merit.

Rather similar are the nail-studded and medicine-containing figures of the Lower Congo and the medicine-containing figures of the Basonge in Eastern Congo. These figures do not represent spirits of any kind nor are the spirits supposed to dwell in them. Nevertheless they are endowed with spiritual power which can be released for the benefit of supplicants. When a nail is driven into the Mayombe figures of the Lower Congo, beneficial or malevolent power is liberated, while in the case of the medicine containers power lies in the properties of the medicine contained in a horn stuck into the top of the head or in a hole in the stomach or merely attached to the figure by a twist of skin or fibre.

Most African people believe in a supreme God. He is considered remote and unapproachable and as having delegated his powers and energies to a pantheon of secondary gods. He is rarely represented in the plastic arts, although Parrinder[1] speaks of a statue of Mawu (the supreme God of the Ewe) in the royal collection at Abomey.

Below the supreme God and more approachable, comes a pantheon or series of pantheons of great gods; these would seem to be the personification of natural forces, the earth, the sea, the sky, thunder, and others; sometimes they are said to have been created by the supreme God to carry on his work, sometimes they are his offspring. On their goodwill a great deal of the happiness of mankind depends. At times they would seem to be confused with the deified ancestors and founders of the tribes.

These gods sometimes have statues which are definite representations of them, the most noteworthy being the figure of Odudua — Mother Earth — of the Yoruba and neighbouring tribes, with her children; and the maternity figures of the Lower Congo. Odudua was in all probability the leader of one of the early invasions of the Yoruba country and founder of one of the earlier dynasties; he slowly became identified with the creator and as such is represented as a female figure carrying one or more children.

[1] Parrinder, *West African Religion*, p. 24.

The possible influence of Christian thought on these representations of the mother and child is discussed later.

MAN-REGARDING ART

Rooster

By Man-regarding Art we mean all art which owes its existence not to religious motives, but rather to the desire for social prestige, or to man's sheer love of symbolic or decorative objects for their own sake (PLATE II).

Works of art of this sort may have a prestige value; they may be recognized perquisites of social rank and be centred on the palace and person of the rulers of the large kingdoms, and to a lesser extent on their supporting chiefs. On a rather more bourgeois level they may yet be the appurtenances of lesser chiefs and 'big people'; while less pretentious but still genuine works of art may be enjoyed and created by the common people as a part of their everyday material stock in trade.

The artist strives continually to give expression to his patron's social ambition and to gratify him. Such dependence has its own advantages and disadvantages as we shall see.

To find such art in its richest form we must seek out the African kingdoms where the life of palace and court has been most highly developed. We should perhaps have expected the great early negroid kingdoms of the Sudan, the kingdoms of Ghana, Melle, or the Songhai, to create the necessary background for such work, but we do not find it there for the Moslem faith forbids carving in human form. There was therefore no development of local figure carving under their influence.

Along the Guinea Coast, however, we do find exactly the kind of background we are looking for.

In the kingdoms of Benin and Yoruba, and further west through Dahomey to Ashanti in Ghana, the social structure has produced a developed and sophisticated form of art which contrasts strangely with the Spirit-regarding motive we have so far considered.

Changes in philosophy or social structure with their resultant changes in the creative arts usually owe their origin to foreign influence. Of very early culture contacts with the outside world and their permanent effects on the art of the peoples of West and Central Africa we know little that we can regard as definite and indisputable fact. We have reports of Phoenician, Carthaginian, and Roman expeditions which must have left their mark, and more and more is being written to-day of Egyptian cultural influences. The influence of the northern Moslem kingdoms on the

sculpture of the Western Sudan appears to have been almost entirely negative, owing to Moslem suppression of figure carving, which led to the preservation of that art chiefly in the more inaccessible forest and mountain areas still occupied by pagan tribes.

The strongest as well as the most mysterious suggestion of foreign influence is shown in the art of the old Kingdom of Ife in Nigeria. Here we find an art which differs in technique, form, and content, from all surrounding types of art. No longer do we find an emotional, childlike, romantic expression of the subjective reaction of the primitive artist to an unknown and rather frightening outer world, nor the Spirit-regarding concentration on ritual values regardless of aesthetic results, but rather a carefully calculated and studied type of personal portraiture, which suggests an intellectual approach entirely un-African in its outlook.

We know little of the early kingdom of Ife, but we can get a vivid picture of Benin from the records of merchants from Europe of over three hundred and sixty years ago. From these accounts we can justifiably credit a certain amount of the development of Bini art to the stimulus of contact with the western world. Contact and trade with the Portuguese and early British explorers must have sharpened the imagination of local craftsmen. But it is clear from the early writers that they were impressed with what they found on their arrival.

Early accounts of the other kingdoms of the Guinea area give us very much the same sort of picture. Herskovits[1] terms art in the kingdom of Dahomey to be 'a basic part of human effort', and lists the sceptres and elaborately carved stools of the King and chiefs as symbols of rank and succession, and the appliqué cloths, brass casting and low-relief modelling on the walls of palace, temples and chiefs' houses to be 'luxury articles, the perquisites of caste'. He describes how, in the days of the Kingdom, the craftsmen, brass casters, cloth workers and the rest were the retainers of the monarch, who dictated the subject and treatment of their work and used it to embellish his surroundings or to present to envoys from other kingdoms. The craftsmen were members of closed family guilds and lived in compounds within the vicinity of Abomey; caste restrictions prohibited commoners from employing them or using their wares.

Art of this kind, therefore, will aim at the glorification of the ruler and of the dynasty; it may find expression in personal portraits (of an idealized type) of the ruling monarch, or it may illustrate the legendary

[1] Herskovits, *Dahomey*, Vol. II, pp. 356, 357.

exploits of the heroes of the tribe and portray their deified founders. It will create symbols of rank such as stools, sceptres and wands of office; it will develop an architecture with accompanying sculpture in the round and low-relief; and associated applied arts such as textiles, furniture, vessels for food and drink, regalia, musical instruments, and so on.

The resulting form will be studied, intellectual rather than emotional, inclined to naturalism rather than stylization, decorative, elaborate; it will aim at a high finish, will tend towards sophistication and in the end to superficiality (PLATE II).

It is always interesting to speculate how great the influence of a foreign invader can be on the art of any country, and we have enough evidence from our own day to come to certain definite conclusions. In our own day in Africa at least, the foreigner will have very considerable influence through his choice and patronage. He will, as a tourist (and in the old days the sailor and merchant adventurer must have played the same role), buy up everything which takes his fancy, and a market is then created in which the native craftsman will attempt to work to satisfy his patron's taste. As the patron will almost certainly have no understanding of the psychological approach to the art of a people other than his own, and will seldom have the artistic sensibility to appreciate formal values which are different from his own artistic tradition, such patronage will unfortunately often have a corrupting effect on local art forms. Work will be admired which most nearly approaches the criteria of the invader's own artistic idiom, or alternatively which is considered crude and quaint. If the demand is great, mass production will set in, and within a very short time the work will have lost all artistic value. We can see this happening all over Africa, especially in centres where air travel brings a large flow of passing tourists for night stops. This large-scale deterioration towards the mass production of curios is, of course, a new phenomenon, but on a smaller scale it must have been going on ever since contact with the outside world was first made.

The tourist-collector influence is one factor; another even more deep-seated one is brought about by missionary and administrator alike through the fundamental change which they make in the indigenous people's philosophy and beliefs. Once the overwhelming belief in the power of the spirits and the efficacy of rituals is broken down, the old religious art must die; this will happen automatically quite apart from any deliberate effort on the part of the invader to suppress art or ceremony which he believes to be immoral. As new philosophy and new

beliefs are introduced and become a part of the people's inner personality, new art forms should arise, and one would hope that in some cases cross-fertilization of ideas would lead to a definite enriching of local art.

Local art is affected by the foreigner in three ways: it may be affected by the introduction of fresh techniques and materials; its form of expression may be altered by the adoption of new idioms or the turning out of new types of applied art; or, most fundamental of all, its whole content of ideas may be changed.

Turning to later influences, European contact in Africa first through the Portuguese and later the French, English and Belgians, must have been marked from the fifteenth century onwards. Although bronze casting amongst the Benin is now considered to be pre-Portuguese, the art may have been developed and encouraged by them among a number of tribes, and the trade in 'manillios or bracelets of copper, glass beads and corrall' would give an impetus to both metal casting and to that of beadwork. Cheap imported paint cannot be considered a blessing when its results in modern polychrome work are considered alongside the restrained colours of earths and vegetable dyes and beautiful natural patina of older specimens. Yet the local craftsman was sometimes ready to discriminate and adapt imported materials to his own good purpose, as is illustrated by the Ashanti weavers who are said to have bought silk textiles from the early Dutch traders in order to unravel them and reweave the silk into the designs which local custom and taste demanded. New materials and techniques will be used, new forms will be copied. The advent of the foreigner is often marked by his representation as the subject of many carvings. From the arrival of the Portuguese onwards soldiers and sailors, government officials, missionaries and tourists have all lent themselves as fresh subject matter for African carving, and the results are often a comic commentary on the way in which the foreigner is regarded. Although these carvings have usually far less formal value than uninfluenced work, yet, simply because they speak of the things which we know, we can appreciate through them the very high skill of the African carver. Each of them sums up the character of its subject in a way which is most extraordinarily subtle and expressive (PLATE III, A). If we find this is so in work the subject matter of which we understand, we may perhaps in imagination realize the power over its African audience of work which is purely African in both content and idiom.

It is in religious art, where Christianity has been adopted in the place of paganism, that we ought to find the most profound and interesting

c

changes of both content and expression. But it is extraordinarily difficult to find works of early original Christian African art which are genuine. The medicine-containing figures of the Lower Congo with their magical material contained in cavities covered with small pieces of looking-glass have been compared with the Christian statues of the saints containing holy relics of the fifteenth and sixteenth centuries; while the nail-studded figures might just conceivably have been based on the nailed Figure on the Cross. Easier to accept is the suggestion that the figures of the mother and child found in both the Benin and Lower Congo areas where early Catholic influence was strong have been suggested or influenced by statues of the Madonna and Child in the early days. Certainly European influence can be felt in some stylistic qualities which are similar in both these areas, notably in the sense of action in figure carving, and in the building up of figure groups. It would not appear impossible that the cult of a Mother Earth goddess, already existent in these areas as in other parts of Africa, received an impetus from the dimly-grasped conception of the Madonna and Child, and so her portrayal, albeit in crude African form quite unlike the draped, sophisticated European type, was developed.

Protestantism did not normally encourage the arts, fearing that the primitive African might place a magical value on material works of art. Catholicism took the risk, and we are given a most interesting account in *The Arts in Belgian Congo and Ruanda-Urundi*[1] published during the Holy Year of 1950. Here we find a description of 'The era of Christ the Redeemer', the first Catholic evangelization of the ancient kingdom of Congo from the end of the fifteenth century to the end of the seventeenth. Here crosses and crucifixes were so absorbed into indigenous culture that they received a type of veneration which differed little from that of fetish objects; on the other hand, even then, as has continually happened since, statuettes of saints and the Blessed Virgin were produced by native craftsmen which were nothing but poor repetitions of poor types of European art and so had no spiritual or aesthetic value. Neither the cross absorbed into fetish cult nor derivative representations of European saints hold any interest for us in this study. Yet here and there one comes upon a work which has real depth and beauty, and one cannot but feel that here the native craftsman has received fresh spiritual inspiration without losing the best of his African approach. Such works are the crucifix shown here, dating from the seventeenth or early

[1] *The Arts in Belgian Congo and Ruanda-Urundi*, Information and Documentation Centre of Belgian Congo and Ruandi-Urundi, 1950, pp. 35 et seq.

eighteenth century, and the modern 'Burial of Christ', a work by an East African art student (PLATE III, B and C).

THE ART OF RITUAL DISPLAY

The Art of Ritual Display might be regarded as the link between Spirit-regarding and Man-regarding Art; for it is Spirit-regarding in that it is used in ritual ceremonies to attract and control spiritual forces for the benefit of living members of the tribe, and from this aspect its ritual preparation and usage will be of as great importance as that of the ancestor figures and other Spirit-containing carving we have already discussed; and it is Man-regarding in so far as it is publicly displayed and planned to appeal in any way to a human audience.

Many objects used on ceremonial occasions can be regarded under this heading, but masks together with the costumes which accompany them are the most obvious examples. It is unfortunate that most museum specimens only show the mask unaccompanied by the costume and accessories with which it was designed as a whole, and that it is impossible for most of us to watch the ritual dance in which it is used, for without doing so we cannot possibly realize its full force (PLATE IV).

In the Dogon myth recounted by Griaule to which we have referred an amusingly human explanation is given of the reason why masks in the Western Sudan are so much more developed and elaborate than figure carving. These masks were not made to be hidden in the sanctuary; from the first they were worn, together with the complete costume of fibre cloak and kilt, in the ritual dance. Here, as well as later, when they were publicly displayed, they excited the admiration and envy of the crowd. Aesthetic values crept in; the audience, for whom the work was designed, was as much the human as the spirit world; and this human world was prepared to go to all lengths, even to that of buying corpses, in order to enjoy the resulting visual and choreographic arts. Thus the masks of the Western Sudan, while retaining the stylized and abstract form employed in the figure carving of the area, also developed a rich and colourful quality of decoration which appealed to the human element. So far the Dogon myth has helped us to 'get the feel' of the psychological and emotional approach to the masks and carvings which we are studying. Regarded from the point of view of their creators and users the masks, as formal symbols created with due regard and ceremony, satisfy the magico-religious requirements of the cult for which they are made and

they also appeal to the need for colour, ornament and design as part of the choreographic ritual in which they will take a leading place.

When an attempt is made to analyze the activities in which masks play a part, it is very apparent that any clearly defined classification is impossible.

A fundamental necessity for all mankind is fertility; fertility of the crops, of cattle, and of the people themselves. In more complex society this fundamental necessity is broken up into so many different aspects that we cease to see it as an emotional whole, but in the more simple background of primitive tribal life, in the more integrated cultures of Egypt, Greece, and the East and in peasant life in Europe we can recognize the same patterns of thought and ritual action. These basic needs are man's chief interest and become the material for his *dromenon* or rites.

Ritual was rightly called by the Greeks *dromenon* — a thing done — and through it certain emotions are re-created and set free. It is but a small step from the experience of these emotions to the belief that the performance of rites causes the desired results to happen. Through the performance of certain rituals, the enacting of certain happenings, rain comes, crops are forced to grow, the tribe becomes more fertile; through the wearing of a mask made of the scalp of an enemy power is obtained; and the mask, the costume, the ritual object carried before the dancers, are not copies or representations of the spirits or powers whose help is invoked; they have become the powers, and the performer who wears them is not acting a part, he is merely the anonymous bearer of the power itself.

The occasions of such rites will be seedtime and harvest, which may include the time of the gathering of wild fruits among peoples of a very primitive economy. The idea of winter and spring, of death and resurrection, of the necessity of death to bring forth life, will lead to the oblation of first fruits and the enacting of animal and even human sacrifices; the feeling that those members of the tribe who have passed through death have thereby gained power to order natural events to the profit of their living tribesmen will encourage elaborate funeral rites and festivals of All Souls which recall to them the predominant interest of the tribe; and in the calling in by representation of cult heroes to assist in the proper tilling of the soil and growing of the crops.

Life and social organization in this more straightforward world will be directed towards this end, daily living will have its share of manual work and ritual acts, both accepted as a normal and equally important part of

the business of life. To quote from Perham:[1] 'If the functions of "Government" among these people are small where ours are large, it operates in a vast realm which the civilized state makes no pretence to control. The leaders of each of these little communities have responsibilities to their people for the working of nature; they must do their part to make the crops grow and the women and stock bear young. . . . The ordinary Ibo believes that his visible and physical life extends in all directions into an invisible world filled with spiritual beings of all kinds; the deities of the sky and the earth, the spirit of the local land and river; the dead members of his family waiting, perhaps, to be reborn; evil spirits ready to do him harm, and the spirits of animals. Society is set within this spiritual world, and, for its advantage or defence, is ritually linked to it on every side. All enterprises, all daily and seasonal events, as well as the accidental and unusual have to be marked with prayer, ritual, or sacrifice. The primitive Ibo cannot pass a day, hardly an hour, without performing some act dictated by his relations with the unseen world.'

In West Africa social organization consisted to a very large extent of groups and secret societies, each with its own functions, rites, and mysteries. These societies had many functions, they united past and present members of the tribe, commemorated the dead at funeral and mourning rites and All Souls festivals, and enlisted their help during fertility rites. Initiation ceremonies and other secret rites upheld the power of the men of the tribe, or of the elders. Some societies were chiefly preoccupied with hunting out witches or punishing evil-doers.

Some society functions would seem to be purely social and aesthetic, when processions and plays and dances were performed in honour of the ancestors of a certain district or town; some were trade guilds, others political. A man's power and social position depended on the rank he had attained within his society; while the power of the departed spirits was represented and upheld by the masked dancers during religious feasts and ceremonies.

Some societies were definitely anti-social, dangerous and greatly feared. They were often associated with cannibalism. The power of the societies tended to be less in regions with a strong central monarchy such as Dahomey and Ashanti; for the monarchy would not tolerate strong rival powers. The more unpleasant forms of society flourished best in the thickly forested coastal areas.

Initiation into full adult status in the tribe, or into the various grades

[1] M. Perham, *Native Administration in Nigeria*, Oxford, 1937, p. 235.

and age groups of the societies, and also many other rites performed by these societies, are essentially mysteries, which must be kept secret from the uninitiated; hence the hideous character of many of the masks worn by members of the more sinister secret societies of the West Coast or by members of the initiation camps of the Congo; and the wide-spread belief that if women or children see such masks or watch performances in which they play a part they will surely die. Such masks will have a powerful quality of emotional expression. In order to keep up the belief of the uninitiated in the authenticity of the appearance of the spirits who return to take part in ritual ceremonies elaborate stagecraft is carried out. Parrinder[1] tells of a Society of the lagoon people west of Lagos where the spirits of the sea come back. 'In the moon-light, two masked figures will draw together, one wriggles out of his costume into the other's, while his own robe sinks to the ground, a proof that the spirit is not a man. Sometimes a masked costume is put to float on the lagoon, and a *zansi* comes up into it by diving under the water, like a lagoon spirit.'

As men become more sophisticated the acting out of their beliefs and desires in ritual dance becomes formalized and stereotyped, and loses its emotional drive; the mystery which surrounded such performances and the object connected with them fades away; the Societies themselves take on more modern political and social functions. Masks are no longer regarded with fear, their wearers carry them openly through the streets to the place of performance, and the original meaning of the annual plays performed is forgotten.

Some dances consist in the miming of animals. In the wearing of zoo-morphic masks certain bird or animal forms would seem to be especially connected with certain tribes, e.g. the antelope with the Bambara, the buffalo with the Bobo and the Gouro, a certain bird with the Senufo. Some writers would say these are totemistic, others would deny it. Among the Baule many of the tribal pantheon of gods are known to be symbolized by certain masks or features on masks. The sky god is symbolized by a ram, the secondary god to whom much of the organization of the world has been entrusted by a bearded mask, another by that of a horned bull, and so on. This may also be the case with other tribes.

From all this we may begin to have an understanding of the psychological reasons behind the many different formal qualities we find in the mask. These qualities might be classified as near-abstract, decorative, naturalistic, architectural and expressive. Near-abstract masks are found

[1] Parrinder, *West African Religion*, p. 146.

chiefly in areas where very stylized archaic figure-carving exists, such as the Western Sudan. In the Congo the stylized masks with tubular eyes are found on the edge of the Bakuba-Baluba area bordering on the Basonge with their more archaic figure carving. These semi-abstract masks are usually profusely decorated with pattern. Decorative qualities are also found in the areas where we should expect to find a highly-finished and more sophisticated art, together with a complicated built-up type which we have called architectural, and others of a strongly natural-istic type. In districts where the power of the more sinister secret societies is strong or where masks are used for scare-crow purposes in connection with initiation camps and ceremonies, expressionism will be strong in the attempt to make the masks as frightening as possible. This is noticeable in eastern Nigeria and in the Kasai area of the Congo zone.

There are a large number of types of mask; some are true masks which fit closely in front of the face, having slits for the eyes, while others of a similar appearance, though often smaller, are worn upon the forehead attached to a fibre headcovering. Some are helmet-shaped and pull right down over the head, others of the same shape are worn as a cap. Some are not worn vertically at all, but rest on the top of the head in a diagonal or even horizontal fashion. Most are carved with a rabbet pierced to take the fibre wig and beard, which often covers the whole head and body.

There would seem to be considerable discrepancy in the way in which masks are regarded and the care which is given them. Amongst the Dogon, although masks are kept hidden in crannies of rock so that the women may not see them, they are carelessly thrown away when worn or damaged. Among some other tribes masks are considered to be cult objects and sacrifices are made to them. They are kept hung in the hut of the Head of the Society to which they belong, smoked by the hut fire, rubbed with fat to preserve them, and in some cases bathed in libations of blood and gruel; thus they obtain their unique patina.

III

GEOGRAPHY, HISTORY AND
SOCIAL PATTERN

The region which we are considering in this study covers a comparatively small part of the African continent, concentrating on the sculpture of the Guinea Coast and its hinterland, the Western Sudan; and a broad strip of land running south-east across the centre of Africa and comprising the Cameroons, the Gabon, the Central African Republic, the Congo (Brazzaville) and the Congo roughly south of a line running eastwards from the junction of the Kasai and Congo rivers to the north end of Lake Tanganyika.

This large area can be subdivided into a great number of smaller districts, each with its own characteristic school of sculpture. The styles of these schools are remarkably consistent and distinct; but naturally characteristics tend to shade off from one area to another, and certain forms are borrowed and assimilated by one group from its neighbour. Even between two regions where the type of sculpture is most distinctive — the Guinea Coast with its highly elaborate and often naturalistic sculpture and the Western Sudan with its simple archaic forms — we find a fringe stretching along the northern territories of the Guinea where the two types intermingle.

The coastal area of the Guinea together with the greater river valleys further north is a region of swamps, mangroves and dense forests, with a very heavy rainfall and almost constant humidity and high temperature, giving way northwards to open forest and savannah, and finally to semi-desert towards the northern borders. This coastal forest belt is broken in Western Nigeria, Dahomey and Eastern Ghana where forest and savannah are intermittent.

The story of West Africa is, as far as we can tell, one of succeeding waves of people from the north and east, pushing the earlier and more

primitive inhabitants southwards into the dense and difficult forest country or up into the rocky highlands of the interior, where living was equally difficult and unattractive to more civilized peoples.

The earliest inhabitants of the country were most probably pigmy; at any rate both the Hamitic Fula and the negro Dogon of the great bend of the Niger hold the tradition that the people were red-skinned dwarfs whom they dispossessed.

The present inhabitants are a black-skinned race with woolly hair, tall of stature and moderately dolichocephalic, with flat noses, thick everted lips and often a considerable degree of prognathism. Linguistically they can be divided into a large number of language groups all belonging to the Sudanic family, while culturally they have many things in common, most notably the secret societies with their accompanying ritual and art.

These people probably came in the far distant and unknown past from the east, possibly from the area of the great lakes, whence they were pushed westwards to the north of the great forest belt by the pastoral Hamites, later arrivals, for there must have been more than one invasion. These pushed the first comers southwards into the forest lands and were in their turn driven south by later comers, negroes mixed with Northern Libyan and Berber blood.

So today we find the coastland and other more inaccessible areas such as the forested river valleys and rocky plateaus in the great Niger bend inhabited by descendants of the first wave of negro invaders, while the more open country is peopled by a rather different type, these latter showing various degrees of modification due to the light-skinned infusion.

The dense forest areas of Liberia and Eastern Nigeria did not lead to the building up of great empires, or even of large united tribal groups, for in the forest communication is too difficult. Men live in small groups in the clearings, cut off from each other by pathless jungle, and unable to unite. The forest, too, held back the invader and protected the earlier pagan negro folk from being engulfed by the later Moslem kingdoms. Cut off by physical conditions from contact with other groups, these people maintained a primitive culture. Early traders, administrators, and missionaries, found them intractable and barbarous; cannibalism, human sacrifice and other forms of cruelty flourished; while the effects of the European slave trade did little to alleviate their sufferings.

The people were socially fragmented, but developed an elaborate

organization within small units, an organization in which the various secret societies played the dominant part. Much that we should consider bestial and abhorrent was done in the name of these societies; yet they were responsible for all social law and order; their strength lay in the integration of the present with the past, the spiritual with the material.

THE WESTERN SUDAN
(The Dogon and Bambara, the Bobo and Mossi, the Senufo and the Baga)

In the hinterland to the north of the Guinea Coast approach was possible from the north and east by various caravan routes, which brought in waves of Hamitic negroes of widely varying types, as well as allowing earlier communication with the peoples of the Mediterranean.

Ptolemy cites two Roman expeditions, the first *c.* A.D. 100, the second somewhat later, which marched southwards across the Sahara. He mentions a River Niger, which would appear to be a combination of the rivers Niger, Benue and Senegal.

Indeed the Sahara did not form such an impenetrable barrier to contact with Carthage, Egypt and later with Rome, as was the sudd which cut off East Africa from easy contact with her northern neighbours, and it is probably due to this that West Africa learnt to build in brick and clay; to work gold, iron, copper and bronze; to cultivate, spin, and weave cotton; and to develop much in her funeral art, and the ideology behind it, which would seem to show definite connections with Egyptian thought.

As time went on a series of powerful kingdoms grew up in the more northern parts of the area, ruled by peoples of mixed Negro and Hamitic blood.

The first of which we hear was the great Negroid Kingdom of Ghana in the tenth and eleventh centuries A.D. or earlier, which stretched across the bend of the Niger from Senegal.

This was succeeded by the kingdom of Melle, a powerful Sudanese state of the thirteenth and fourteenth centuries. Melle was a famous mediaeval city situated towards the headwaters of the Niger, and this kingdom, like that of Ghana, was made up of Mandingo tribes.

Rather more to the east another group of negroid people with a strong infusion of Hamitic blood, the Songhai, established a kingdom with its capital at Goa on the central Niger near the Sokoto river. This kingdom, which was strongly Moslem, grew in power until it captured Melle in about A.D. 1500. By the sixteenth century its rule stretched from Lake

Chad to the Atlantic, and its importance as a centre of trade between West Africa and the Mediterranean was very great; it was finally conquered by the French with the fall of Timbuktu in 1893.

The Hausa, a negro people akin to the Songhai, speaking a Hamitic language, who are now to be found all over the northern provinces of Nigeria and constitute more than one-third of the population, were once a confederation of seven states which were conquered in the early part of the nineteenth century by the Fula.

The Fula, who are first heard of historically as settled in Senegal and are probably of Libyan extraction, spread eastwards during the days of the Ghana Empire, and found their way into northern Nigeria by the end of the thirteenth century; they conquered the country and are still the dominant political power.

Thus we see that infiltration of Libyan blood from the north into Western Sudan had been taking place from early times, but the pressure was greatly increased after the expulsion of the Moors from Spain at the end of the fifteenth century, which led the peoples of north Africa to turn their attention south. But little was brought down of the great tradition of Moorish art, and the early kingdoms seem to have developed practically nothing of their own. On the whole Moslem influence from the north did remarkably little to break up the old pagan beliefs and practices except in certain centres; on the contrary it tended to drive the more primitive peoples into inaccessible forests or rocky strongholds where the art and ritual associated with their beliefs could flourish undisturbed.

In this area, then, as in the thickly forested portions of the Guinea Coast, we shall expect to find that it is the art of these more primitive peoples which will interest us most. In some of these tribes, notably the Dogon, there is a striking resemblance between many of the funeral customs and beliefs and even the figure sculpture itself with that of Egypt, suggesting early contacts. In the Dogon myth, too, which we have discussed earlier, it is stated that the whole complex of art and ritual was taken over by negro invaders from the 'little red people', the original inhabitants of the country. The existence among all the tribes of the zone, except the Dogon, of a specialist craftsman caste is taken by some as a further indication of the existence of a submerged and conquered race. Lem[1] says that all work that requires a specially skilled

[1] F. Lem, 'Sculptures Soudanaises', *Arts et Métiers Graphiques*, Paris, 1948, pp. 18 et seq.

craftsman is performed by a special caste of people who are both scorned and feared. They live apart, intermarry, have their own customs, and pass on their own traditions and skills. This, he believes, proves them to be the descendants of the original population, more technically skilled than their conquerors, who make use of them to supply their needs. The fact that the Dogon have no such specialist caste he takes as a proof of their being themselves one of the very early peoples of the country, driven into the hills by later invaders. Griaule,[1] on the other hand, denies that the craftsmen are a caste apart, or are feared and despised. He quotes the highly honourable position which they hold in some tribes; and would say they are merely skilled and trained specialists to whom, naturally, the ordinary man gives out his work. They are expected to have no magic powers or secret customs; when necessary, the work is afterwards consecrated by professional priests. The arguments on both sides are interesting, but do not seem to be conclusive.

Amongst these people then we shall find an art which is closely tied to the old pagan religion; and as in the more open savannah country permanent agricultural communities were built up with economic dependence on the soil, the practice of agrarian fertility rites, in which dancing and the carving and use of masks and figures took their part, developed.

The tribes of this area whose art is specially worthy of study are the Dogon and Bambara, the Bobo and Mossi, the Senufo and the Baga.

The Dogon inhabit the mountainous country in the plateau of the Niger bend. This district has always been a refuge for the more primitive tribes from later invaders and, fortifying themselves in their rocky caves, they have resisted Moslem influence and retained much of their old religious custom. Their religion is organized by a hierarchy of priests, the *Hogon*, who live a life set apart from the rest of the community and wield great power. Both their funeral rites and their ancestor carvings have a certain affinity with those of Egypt. In contrast with many of the Sudanic tribes, the carving of masks, worn by the young men of the Society *Nama* during their annual ceremonies, and at other ritual dances connected with the burying of the dead, is done by the young men themselves and not by specialist craftsmen. The artistic centres of the tribe are at Hombori and Douenza.

The Bambara are a large and important tribe of the Mandingo group found in the area roughly bounded by 11°–15° North and 6°–9° West. They are hardworking agriculturalists, living in small villages, and have

[1] Griaule, *Arts of the African Native*, p. 103.

shown great resistance to Moslem influence. Their carving is the work of specialist craftsmen, and amongst them the occupational guilds are of great importance. The Society *Chi Wara* is connected with agriculture, and the very remarkable and lovely antelope crests of this Society are worn for agricultural ceremonies.

The Bobo appear to be a very primitive people who may have settled in their present area before the arrival of the Mossi in the eleventh century. They have no strong central organization and are much divided linguistically. They are animistic, sacrificing to the earth, sacred trees and rocks. There are two centres of art, one at Dioulasso, the other at Tougan. The Society *Dou* celebrates agrarian festivals with masked dances.

The Mossi comprise a large proportion of the population of the Mali; they are centred round Ouagadougou, which is the seat of the king and his government, and extend into the north-west provinces of Ghana.

They would appear to have taken over their religious customs from the original inhabitants of the country. They have a strong social organization, and are pagans with a sun and moon cult. Ancestor worship plays a large part in their religious life, and the masked dances of the society *Wango* are connected with burial ceremonies and certain rites centring round the gathering of wild fruits. This last is a vestige of a very primitive stage of existence when the culling of wild berries was a very important part of tribal economy.

The Senufo, who may be found between 8° and 13° North and 4° and 7° West, are made up of a collection of peoples separated often by other tribes and differing among themselves in language and culture. They are a peace-loving people who owe much in their culture to their various neighbours. Stretching as they do from the hinterland southwards to the Ivory Coast, they have, as we might expect, an art which is transitional between that of the Western Sudan and of the Baule in Guinea, exhibiting some of the characteristics of both. Their figure carving would appear to be more nearly akin to the former, although it has a very marked individuality of its own.

The Baga are found on the coast of Guinea. The affinity of certain characteristics of Baga art to that of the more central tribes in the Western Sudan is explained when we find that they reached their present position on the coast comparatively recently, having come from near the source of the Niger and being considered a part of the Mande or Mandingo people to whom the Bambara also belong.

GEOGRAPHY, HISTORY AND SOCIAL PATTERN

THE SOUTH-WESTERN GUINEA COAST
(*The Mende, the Dan-Ngere tribes, the Gouro and the Baule*)

Working eastwards round the southwest coast of Guinea we shall note the Mende who form the greater part of the population of the Central and Southern Provinces of Sierra Leone, in whose art are included both the ancient soapstone figures found in the district and striking contemporary helmet masks; and further inland to the east the complex of Dan-Ngere tribes whose powerful masks range from the extremes of abstraction and realism, all connected with society cults.

Further east still are the Gouro and Baule people, the Gouro being the more ancient tribe in the area, the Baule arriving at their present position in the middle of the eighteenth century and partially assimilating the original inhabitants; both tribes produce work of great sensitivity.

THE KINGDOMS OF THE CENTRAL GUINEA COAST
(*Ashanti, Dahomey, Yoruba with Nok, Ife and Benin*)

In the more open woodland type of country of the coastal region and its hinterland higher types of civilization were to be found, for of choice the more developed tribes settled there, and the influence of foreign culture made itself felt through greater ease of communication, both from the north and from the southern coast.

When we search back into recorded history we find traces of penetration from the civilized world from a very early date.

According to Herodotus the Phoenicians sailed down the Red Sea, rounded the Cape, then sailed up the west coast of Africa and back home through the Mediterranean in the sixth century B.C. In the succeeding centuries the Carthaginians established trading stations on the west coast as far south as the Rio de Oro.

About 470 B.C. Hannon, a Carthaginian general, reached the Senegal river and pushed on down the coast, possibly as far as Sierra Leone. There were probably also overland trading routes across the Sahara and by these or by sea, contact and trade were kept up; until in the third century B.C. we find the Carthaginians trading ivory, gold and negro slaves in the Mediterranean ports.

In this more open country then we find not only traces of the influence of early Mediterranean civilization, but also a much stronger admixture of Sudanic blood.

KINGDOMS OF THE CENTRAL GUINEA COAST

These Sudanic peoples developed a number of highly organized kingdoms, in some cases historically closely related to one another; all of which built up the kind of social structure in which the patronage of the king and his court produced an art showing many of the characteristics which we have suggested would naturally be found where the craftsman's motive was Man-regarding.

When we come to consider the background of these central kingdoms of the Guinea Coast it is extraordinarily difficult to build up a balanced picture. Their early history, consisting so often only of legend, is that of the wanderings of primitive tribesmen, throwing up from time to time heroes whose deeds become myths; the lives of many of their people must have been spent in extreme poverty, and much of their custom would seem to us cruel and degrading. Yet set against that we have evidence of very highly organized political and military power, and an autocracy consisting of the king and his court, and the provincial chiefs and their courts, in which great social prestige was maintained by the display of material wealth expressed through the arts. That these people did in fact reach a very high aesthetic standard in their arts is evident from the carvings and examples of applied art which may still be seen; we have, too, the descriptions of the early travellers from Europe who were both surprised and impressed by what they found.

More has been written of the Kingdom of Ashanti than of many others whose art we are considering. Cut off by dense forest from the penetration of Hamitic peoples from the north they built up a highly-organized political state with strong military power. The king was paramount; but the provincial chiefs in their turn lived in semi-regal state; and a council consisting of the queen-mother, the most important chiefs, and military generals had much power. The African belief in the unity of all members of the tribe both living and dead, and the still potent presence of the ghosts of the kings is well illustrated in descriptions of the great Yam Ceremony (as it is known to Europeans) in which wine and new yams were sacrificed to the ghosts of the kings amidst an orgy of drinking and blood spilling. Such ceremonies were described by early writers as meaningless demonstrations of savagery, but they served their purpose in unifying the tribe, and are of especial interest to us in that this aristocracy of the living and the dead gave cause for highly skilled craftsmen to produce cult symbols and luxurious objects of art.

The kingdom of Dahomey consists of Ewe-speaking peoples. In the seventeenth century the people of a southern state, Adra or Allada,

pushed north into the country round Abomey. In the early eighteenth century the Dahomeyan kingdom drove southwards and captured Allada and pushed the people of the neighbouring state of Whidah down to the coast, thus opening for themselves communication with the sea and with the European. A powerful kingdom was developed throughout the nineteenth century with an elaborate court life, a strong military organization, and a somewhat sophisticated art such as we should expect of a country ruled by a powerful aristocracy. Herskovits[1] quotes from Forbes who went on two missions to Dahomey and resided in the capital in 1849 and 1850, an inventory of the king's wealth, including many silver ornaments carried by men and women; and also Skertchly's description of a ritual procession in 1874 in which were carried 'a tall silver candelabrum in the form of a tree, about five foot high, with candles of silver; a six foot silver stork; a crow; an immense silver skull, and a smaller silver tree about four foot high, all the workmanship of the royal silversmith'.

The kingdom was in constant conflict with the Yoruba to the east, and today Yoruba-speaking people are grouped all along the eastern border and stretch right across the country in the north into the Independent Togo Republic.

The historical background of the Yoruba with Ife and Benin must be considered together, for Ile Ife was the original cultural and religious centre of the country; while in the twelfth century Benin became the vassal state of the Yoruba.

The Yoruba now occupy the western part of Southern Nigeria from the borders of Dahomey in the provinces of Oyo, Abeokuta, Lagos, Ijebu and Ondo. Their story is of migration from the north, with legendary leaders who became identified with the gods in local myth.

Between A.D. 700 and 1000 semi-white invaders penetrated through Borgu and Nupe into the Yoruba country. Tradition has it that from the sixth to the seventeenth century the country was a vassal state ruled by a dynasty of Nupe blood. But the Nupe did not have unlimited sway in Yoruba, for in the twelfth century a king or prince of Borgu invaded the country from the north. This man was Odudua, and through subsequent legends he became identified with the earth goddess, so that the name can signify both the founder of the state and goddess of fertility.

Inter-marriage between the royal houses of Borgu and Nupe followed, although rivalry between the two powers doubtless continued. Shango,

[1] Herskovits, *Dahomey*, Vol. II, p. 356.

the great-grandson of Odudua by a wife who was a daughter of a king of Nupe, represented both dynasties. Again for us there seems to be some confusion between god and ruler, for Shango as the god of the sky and symbolized by the thunderbolt, the meteorite and the double axe, with the ram as a sacred animal, may be the Egyptian god, Amum, brought by the early travellers from the East.

At its height Yoruba was a large kingdom extending to the west beyond the present political bounds of modern Nigeria into Dahomey. It was always coming into conflict with the Kingdom of Dahomey centred on Abomey, and war went on intermittently in the eighteenth and nineteenth centuries between Oyo and Abomey.

At the beginning of the nineteenth century the whole of the Ilorin Emirate formed part of the Yoruba or Oyo Kingdom, and even today the larger part of the population are still of Yoruba race and language.

To the east the Kingdom included the Ondo and the Ife; to the south-east the Ijebu; to the south the Egba of Abeokuta; while Dahomey and some of the Popo, the Bariba (Borgu) and Tapa (Nupe) acknowledged Yoruba suzerainty. But in spite of seeming unity the state became a military power living on the spoils of expeditions and soon was rent with divisions; the story of the latter half of the nineteenth century is one of constant warfare between one group and another, until in the end various treaties were arranged by the British Administration, and boundaries fixed between certain tribal groups.

In Northern Nigeria very early sculpture dating back to a period between 500 B.C. and 200 A.D. is found at Nok. This culture owes its discovery to the spoil heaps of the tin mines in the area. These important works show a wide variety of form but have, at the same time, a strong unity of style.

One small pagan tribe of the present day, the Afo, situated south of Nok towards the confluence of the Benue and the Niger, produce some interesting carving of considerable strength and character.

To the art historian Ife presents a most intriguing and insoluble problem, for the ancient art found in that one small locality is of a completely un-African character in its approach to its subject matter, and we have no reliable clue as to how it came about.

Here in 1910 the German Inner African Research Expedition directed by Frobenius discovered a number of terra cotta heads together with a bronze known as the Olokun head. In 1938 a further series of bronze heads were excavated during building operations within the precincts of

the old palace. These heads differ completely in conception from work from any other source in Africa save the Tada bronzes, to which they would seem to be related.

The peculiar style and quality of these bronzes and terra cottas will be discussed later, but, briefly, we have here a highly intellectualized and measured form of art, whereas in that of all other African schools the emphasis is emotional and expressive. We have no evidence to help us solve the mystery of when and whence this classical form of art came to Ife; for many years it was thought that the art of cire perdue bronze casting (the technique used in the Ife bronze heads) could not have been known in Africa before the arrival of the Portuguese in the fifteenth century, but that theory is no longer generally accepted, and the bronze heads are provisionally dated from the twelfth to fourteenth centuries or earlier.

To the east of the Yoruba, inhabiting the country immediately west of the river Niger are the Edo; a group of fairly primitive tribes, amongst whom the Bini (the people of Benin to whom strong Sudanic influence was imparted by the Yoruba) are the most important.

We first hear of Benin as a vassal state of the Yoruba in the twelfth century, but its civilization developed more highly than that of its fore-runners. Towards the end of the thirteenth century the ruler of the Yoruba is said to have sent his bronze-caster Ighe-Igha to Benin and introduced the art of bronze casting there.

The Bini were a warlike race and built up one of the most powerful of the great African empires of the Middle Ages. Many elements in their culture seem to have been derived from the Yoruba, as well as the tech-nique of bronze casting. From the end of the thirteenth century a dynasty of kings from Ife seems to have reigned in Benin, spreading the boundaries of the kingdom as far west as Lagos and as far east as Bonny.

In 1485 Fernando Po made a treaty with the Kingdom of Benin, and in the same year the King of Portugal sent an envoy to the country. In the next year he returned to Portugal taking an African envoy with him, who was shown the power of Portugal, converted to Christianity, and persuaded to enter into trade agreements before being returned to his own country. A trading station was opened up near Benin, and the Portuguese began to trade salt, cloth, wire, metal utensils, fire arms and powder for pepper, smoked fish, palm oil, gum, ivory, cattle and slaves. They also introduced a number of important crops such as oranges and lemons, maize, cocoa and tobacco.

In 1589 London merchants speak of 'Pepper and elephants' teeth, oyle of palme, cloth made of cotton woll very curioysly woven, and cloth made of the barke of palme trees' procured in exchange for 'cloth both linnen and wollen, yron works of sundry sorts, Manillios or bracelets of copper, glass beades and Corrall'.

'They have also great stores of cotton growing . . . also many pretie fine mats and baskets that they make, and spoones of elephants' teeth very curiously wrought with divers proportions of foules and beasts made upon them.'[1] Further reports of Benin in 1668 are quoted by Talbot:[2] 'The King's court or castle is square and stands at the right side of the town to one entering by the Ugwato gate. It is quite as large as the town of Harlem and surrounded by a special wall. It is divided into many magnificent dwellings and has beautiful long square galleries which seem about as big as the Exchange at Amsterdam, but one is larger than the others. Its roof rests on wooden pillars covered from top to bottom with cast copper engraved with war deeds and battles. Everything is maintained very clean. Most of the King's houses are roofed with palm leaves instead of shingle, and every gable is ornamented with a turret ending in a point. On these stand birds cast out of copper, with wings outspread, very artistically done from life.

'The town has thirty quite straight streets. Each is about 120 feet broad. And into these come many broad, but somewhat smaller cross-streets. . . . The King's court — the first place we came into — is a very long gallery . . . sustained by fifty-eight strong planks about 12 feet high, instead of pillars. These are neither saw'd nor plan'd but only hacked out . . . at the top of one turret is fixed a large copper snake, whose head hangs downwards; this serpent is very well cast or carved, and is the finest I have seen in Benin . . . the planks upon which the third gallery rest are human figures; but so wretchedly carved that it is hardly possible to distinguish whether they are most like men or beasts; . . . behind a white carpet we are also shown eleven men's heads cast in copper; and upon each of these there is an elephant's tooth, these being some of the King's gods.'

The natives, the forest, and tropical disease, however, proved too much for the Portuguese. Mission work was only struggling by the end of the seventeenth century and the trading station near Benin closed down by the end of the eighteenth century. In the sixteenth and seven-

[1] Talbot, *The Peoples of Southern Nigeria*, Vol. I, p. 159.
[2] Op. cit., p. 162.

teenth centuries Benin was a prosperous state, but in the eighteenth a decline set in, and the city became the centre of religious fanaticism and human sacrifice.

THE EASTERN FOREST BELT OF THE GUINEA COAST
(The Ijo, Ibo, Ibibio and Cross River tribes)

In the eastern portion of this coastal forest area we shall study the art of the Ijo, Ibo, Ibibio and Cross River styles. This is a very arbitrary and generalized division, and would be totally inadequate for detailed study of tribal art, for many tribes are represented within these groups, and on the other hand certain types of art carry across from one group to another.

In the Niger delta are found the Ijo and the Sobo, archaic peoples with a certain amount of Yoruba and Ibo influence.

The Ibo-speaking people cover the large area of the Provinces of Benin, Calabar, Ogoja, Onitsha, Owerri and Warri of Southern Nigeria; they number over 3,000,000 people, and, as they may be divided into at least thirty different tribes, they show marked differences in culture and language. At some time in the fifteenth century the Ibo pushed down into the north-west of Calabar Province and drove out the Ibibio aborigines.

The provinces of Owerri and Calabar to the east of the Ijo are inhabited by semi-Bantu-speaking people, the two largest tribes being the Ibibio to the west and the Ekoi to the east of the Cross River. It seems probable from specimens of bronze work found in the locality and other indications that the Carthaginians established a trading post on the Cross River about 500 B.C.

In 1472 the coast of Calabar was discovered by the Portuguese. The local people were reported both by the Portuguese, and later by the British, to be fierce and cruel, and even a short forty years ago were officially reported to live on an almost sub-human level. In thickly forested areas such as this it is to be expected that only a primitive level of civilization would be reached, and that the less pleasant characteristics of secret society domination would survive. Certainly, in contrast with many societies in other areas whose power was on the whole beneficial to the tribes, some here seem to have been dangerous, anti-social, and very much to be feared. Human sacrifices had to be provided, and ritual included cannibalism.

As an instance of this, according to Talbot, the most important society amongst the Ibo of the Awa and Kwa regions, and stretching right through the greater part of the Ibibio country, and even reaching the Ekoi, is the *Ekpo Njawhaw* — the society of ghosts and destroyers. Great brutality is connected with this society, which is a very ancient one. Its principal object was to propitiate the Ekpo or ancestors, in order to obtain fertility for the tribe and their crops. At the great festivals of planting and harvest human sacrifices were made before huge figures of the gods, chief of whom was Eka Ekpo, the mother of ghosts. The members were usually attired in grass kilts and fringes dyed black, wearing hideous black masks, often in the form of a skull. This is confirmed by Murray,[1] who says: '*Ekpo* is a male society that is said to have been captured in the distant past from women. In former times all males belonged to it and its duties were to propitiate the ancestors for the welfare of the community, to uphold the power of the elders and to maintain the social order. Its rituals were secret and any non-member who witnessed them was killed. During the celebrations, which took place every other year, the masked members armed with bows and arrows or machets, lurk along paths to shoot or waylay non-members who have the temerity to be about. . . . The masks represent spirits from the underworld. They are carved in soft wood and are polished and sewn to a mass of raffia which covers the wearer down to his waist. The rest of the body is blackened. Miming is done in keeping with the character expressed in the carvings and successfully expresses something wayward, dangerous and irresponsible in its action.' The art of these people is very largely confined to masks for the use of these societies, and it is not surprising therefore to find many of them particularly gruesome and sinister. It is the intention of their makers and wearers that they should be so.

THE CAMEROON GRASSLANDS
(*The Bamum and Bali tribes*)

In the Cameroon grasslands the people are, like those of the Calabar, semi-Bantu. But this open country was more amenable to invasion than the thickly forested coastal region, and consequently there were more influential Sudanic inroads. Some tribes, such as the Bali, are very strongly Sudanic. Throughout the country there are interesting signs of

[1] Murray, 'Masks and Headdresses of Nigeria', Exhibition Catalogue, 1949.

a very early superior civilization. Although the well-developed political and military state was not found here as it was in the central Guinea kingdoms, yet royal patronage has done much to encourage the arts in the Cameroon grasslands. Neither secret society nor ancestor worship seem to be very strongly developed here; large masks are worn at burial ceremonies, but the greater part of the art of all the tribes seems to be devoted to secular purposes. Professional craftsmen are hereditary, but their wares are traded over a large area, and this leads to homogeneity of form.

THE SOUTHERN CAMEROONS AND THE GABON
(The Duala, the Fang, the Bakota, the Mpongwe and the Bakwele)

In the Southern Cameroons, the north of the Gabon and in Spanish Guinea are found the Fang, a collection of immigrant tribes probably Sudanic in origin, who came from the north-east during the last century. These people have spread over a large strip of country, arriving in successive waves of small family groups, and mixed in varying degrees with the different Bantu tribes whom they found. The Fang pushed many of the indigenous Bantu tribesmen before them; in the Southern Cameroons, for instance, the Bantu people were driven west towards the coast.

Further south in the Gabon come a number of tribes which are of an intermediate type between the Bantu of the north-west and those of the south of the Congo. These include the Mpongwe and Balumbo. The Bakwele are neighbours of the Fang to the east, and the Bakota to the south-east.

THE CONGO

For our purpose of studying the outstanding schools of African art we have chosen only certain of those tribes who live in the southern Congo south of a line running east from the junction of the Kasai and Congo rivers to the north end of Lake Tanganyika, omitting all mention of the less important work to be found in the north.

This southern area consists chiefly of hot humid savannah and parkland, with thick forest clothing the river valleys. It is divided into a number of wide-spreading kingdoms, each consisting of a large number of tribes, mostly dominated by peoples from the south-east.

THE LOWER CONGO
(*The Congo-Kwango area*)

Starting in the west we have two coastal kingdoms, those of the Lower
Congo and the Loango. The Lower Congo region covers the country
north and south of the mouth of the Congo and stretches eastward as far
as lat. 20° E. The ancient kingdom of Congo itself reached roughly from
south-east of the Congo river to the Kwango, and from Stanley Pool in
the north to long. 8° in the south.

This kingdom of Congo was early brought into contact with the out-
side world, for the Portuguese Diego Cao discovered the mouth of the
Congo in 1482, and during the sixteenth and seventeenth centuries the
country was strongly under the influence of Franciscan and Dominican
missionaries, having as its capital San Salvador. But this contact came to
an end, and by the end of the nineteenth century all that was left was
ruined churches and few Christian symbols adopted into fetishism.
Indeed an interesting comparative study might be made of the early
histories of Benin and the Lower Congo. Both were opened up to the
church and to western influence by the Portuguese in the late fifteenth
century; both proved too hard a task to civilize and lapsed back, only to
be reopened in the later half of the nineteenth century. In the art of both
we find suggestive traits of western influence, such as a developed
naturalism and sense of movement, and the building up of figure groups.

To the north-west of the Congo kingdom lay that of Loango, which
consisted of a number of tribes, including the Bavili and the fore-
runners of the Bateke in the interior. At the end of the sixteenth century
the Portuguese explorer Lopez reported the kingdom of Loango to be a
tributary state of the kingdom of Congo, but during the seventeenth and
eighteenth centuries it apparently enlarged its boundaries by conquer-
ing the Mayombe.

THE LOWER CONGO
(*The Kwango-Kasai area. The Bambala, Bayaka and Bapende tribes*)

To the east of the old Congo kingdom comes the area between the
Kwango and Kasai rivers. This is inhabited by a very mixed collection
of both early and primitive tribes, and invaders from north and south.
To the north of this area come the Bambala, a tribe whose sculpture is
worth noting. The peoples of this region also include the Bayaka, who
over-ran the kingdom of Congo in the sixteenth century. These Bayaka

with the Bapende, a tribe driven up from the south in the early seventeenth century, are artistically some of the most interesting people of the whole region. The importance of initiation rites in their social structure leads to elaborate masks of the scare-crow variety.

THE BAKUBA
(The Bakuba or Bushongo, Bena-lulua and Dengese tribes)

This kingdom covers the Kasai-Sankuru area. A number of tribes throughout this country acknowledge the supremacy of the Bakuba, a people who came from the north, but who owe many of their customs to contact with the other great kingdoms in the south and west.

Artistically the Bakuba are one of the most highly developed peoples of Africa; for not only does their figure carving reach a very high standard, but the decorative carving of their innumerable boxes and other vessels and the patternwork of their woven fibre cloth are extraordinarily fine. This last craft is said to have been brought from the Bapende in the south-west by the Bakuba hero and leader, King Shamba Bolongongo, who reigned early in the seventeenth century. This famous king has now become a cult hero. To him is attributed all that is good in the tribal economy; he is said to have travelled far and brought back many discoveries and crafts. He encouraged the craftsmen's guilds and gave them political power, and this regard for good craftsmanship seems to have continued down the years. When Torday visited these people in the early days of this century he reported that no boy could be initiated who had not learnt to make the very beautiful local matwork, and that every son of the royal house had to be a skilled smith.

To the south of the Bakuba come the Bena-lulua, and to the north the Dengese, both peoples who have developed a highly decorative form of carving.

THE BALUBA
(The Baluba and Basonge, the Balunda and Batshioko tribes)

The Baluba people spread across a great area of the south-east of the Congo from the line of the Rift Valley in the east (Lakes Tanganyika and Meru) to the eastern Kasai in the west; and from lat. 4° S. in the north to the source of the Lualaba in the south, with the country of the Balunda and Batshioko stretching further to the south-west.

Baumann suggests (after Verhulpen) that the language and culture of the area have been welded together from those of a series of indigenous tribes with two dominant invasions from the north; one of a patriarchal people now represented by the Basonge in the north-west, and the other a matriarchal group occupying the country further south and east. These peoples founded wide-spread empires governed by paramount chiefs. It is suggested that there are physical and cultural signs of Hamitic blood among them.

The whole area includes a large number of tribes, and very naturally there are many variations and sub-styles to be differentiated in the art of such a wide-spread group.

The great Balunda kingdom to the south-west of the Baluba was developed early in the seventeenth century by a Baluba hunter who married the local chief's daughter and founded a Baluba dynasty amongst the Balunda. At the same time the two sons of the old chief, who had been disinherited, migrated with their people and spread the Balunda culture far afield. One went westward and contacted the Portuguese early in the seventeenth century, founding a kingdom on the Kwango. The other went south and subdued the people on the Congo-Zambesi watershed. Still other Balunda over-ran the tribes, including the Batshioko, south and west of the Kasai; and others spread towards Meru. In the later half of the nineteenth century the Batshioko revolted and overthrew their Balunda conquerors, but by the end of the century they were again overcome and split into smaller groups.

IV

A BRIEF CRITIQUE
OF AFRICAN SCULPTURE

The aims of the student of art and the student of ethnology are not the same, although they may have much in common. The student of ethnology will concentrate almost entirely on the historical and sociological values of the object which he is examining, and will be interested in form and style only as an aid to classification. The student of art on the other hand will approach his study from the opposite end; for him the formal values will be the chief interest, the obscure specimen may or may not be of importance to him, and he reserves his right to consider one piece which he believes to be of artistic merit, and to ignore another which he believes to be of none, no matter what their relative importance to the ethnologist may be. Nevertheless, in the definition which we have accepted of the effect of a work of art on the observer as being both sensed and realized, it is implicit that the serious student of art must attempt to acquire some understanding of the background against which the work is created.

We have now made a very brief survey of the geographical and historical background and resulting social pattern of the peoples whose art we wish to study, and have attempted in greater detail to work out for ourselves the demands and opportunities which the social structure will present to the artist. For the form of African art is as clearly controlled by the purpose and philosophy of its patron as is the art of every age and race.

In employing the term classical in our title we have used it in accordance with one definition in the *Concise Oxford Dictionary* — that is, of admitted or allowed value. Those pieces which we shall study, therefore, will be for the most part collected specimens the value of which is already acknowledged. We shall not seek for fresh discoveries; we shall not

spend time on either individual specimens or types of little artistic merit; we shall attempt to come to some understanding of the ecology of the pieces in so far as it helps our more specialized appreciation, but we shall leave the more detailed arguments as to the precise social significance or the exact provenance of them to the ethnologists.

THE WESTERN SUDAN
(The Dogon and Bambara, the Bobo and Mossi, the Senufo and the Baga)

The two common forms of sculpture to be found in the Western Sudan are the ancestor figure and the mask. Although the accounts of the ethnologists differ in detail and interpretation, the general trend of their observations is that these ancestor figures have been prepared to attract and contain the spirits of the dead in some form or other, and that ritual observance in their preparation and use is of cardinal importance. When we considered what the visible effect of this attitude might be, we concluded that the artist would feel under no compulsion to express to other men his emotions concerning the spirits, nor would he specially desire to win their approbation; he would simply aim at a properly prepared traditional symbol; this might reasonably be expected to free him in the actual carving to enjoy purely formal values. When we look at the carvings themselves this is precisely what seems to happen.

The art of the Western Sudan has been described by various writers as primitive, simple, symbolic, abstract, static, and introvert; a still better term might be archaic. For in contrast with the art of the Guinea area, which can be found in every stage of naturalism and elaboration up to an almost rococo state, it shows many formal resemblances to the archaic periods of other great arts. The figure carving in particular follows a severely simple and stylized formula. It is completely static, and makes no attempt to express either action or emotion. It is even possible to work out a detailed schema which is amazingly consistent in spite of the well-marked differences of the smaller tribal areas into which the whole zone must be subdivided. This schema can be followed out in the work of the Dogon, Bambara, Bobo, Mossi, Senufo and Baga, who comprise the most artistically important groups in the area. It runs as follows:

The ridge of the nose is, in profile, in the same plane, or continues the same curve as that of the forehead, the nose is long and narrow, sometimes accentuated into a beak or ridge.

The area of the front of the face from the brows down across the front of the cheek bones, the mouth and the chin, is treated as one plane. This plane is usually tilted forward producing a marked prognathism.

The chin itself is usually lacking, the face ending abruptly just below the lower lip.

The neck consists of a narrow upright cylinder.

The trunk is considered as three separate and distinct areas. First one stretching across the deltoid and pectoralis muscles and breasts, appearing as a complex whole very separate in form from the rest. The breasts in the female point forward horizontally.

Secondly the length of the trunk represented by a narrow cylinder, often sloping forward to the navel.

Thirdly the area of the buttocks represented with the thighs as a solid ring into which the upright trunk is fitted.

The arms are thin and straight, often held parallel to, but apart from, the body with the hands often resting on the knees or thighs.

The legs do not appear to be considered to be of much importance, they are often more roughly carved than the rest of the figure, with very small shapeless feet; or are short out of all proportion.

This simplified schema is not merely a chance formula produced by the unobservant and unskilled 'primitive'. Every tribal school has its predilection for certain forms which are produced consistently and with considerable technical ability. Some will seek to emphasize the rounded curves of the human form, others will stress the sharp angles between one plane and another. In most cases the head will receive the most considered treatment, as it does in the art of most of mankind; some will smooth away the accidents in the form so as to reduce it to its most simple shape, others will emphasize one feature or one collection of planes beyond all recognition; yet others will consider the head as a field for complicated linear decoration. These tribal characteristics must be considered separately (PLATE V).

Turning to the masks of the Western Sudan we find that they, too, fit in with the theories which we have developed on the relationship of form to motive. These masks are used for ritual display; they are therefore showy and striking in a way in which the ancestor figures are not. Again, although they are connected with the rites of various societies, we do not gather from the accounts of the writers that these societies seek to bolster up their power by instilling fear into non-initiates, as is done further south. There are occasional references suggesting that the

masks must be hidden from the eyes of women and children, but not the continual accounts of masked figures seeking to petrify all and sundry. When we study them we find no trace in the masks of romantic expressionism, no attempt to carry across emotions of fear, as we certainly find in the masks of other tribes where the mysterious power of the secret societies is emphasized.

The masks are spectacular, although different tribes show this quality in different ways. The Bambara, for instance, concentrate on building up wonderfully-balanced pieces of three-dimensional design carved into arabesques in their antelope crests; while the Baga, the Mossi, and the Bobo decorate the surface of their masks with bold pattern in colour. There are certain types of mask which are found throughout the area and even further, and should not properly be considered the mask type of any one tribe, although when more or finer specimens of a type are reported from a particular tribe it is natural to do so.

One type of mask, which is naturalistic though formalized, is found chiefly among the Bambara, although very similar specimens are reported from the Mandingo and the Senufo.

The mask is anthropomorphic, the face being stylized into a long triangle, while the front below the brow is represented as a single plane divided by the long straight narrow nose. The head is surmounted by a parallel row of some four to eight antelope horns; in some cases a human figure takes the place of the central horns. Both horns and face are often decorated with cowrie shells. Among the Bambara these masks belong to a society of young boys called the *Ntomo*, and are used in their rituals.

The Senufo have a type of mask which in form corresponds closely to the above. The face is moderately naturalistic, but is covered with sheets of beaten brass decorated with cicatrices. The head is surmounted with a row of six or seven parallel straight short horns, with the addition of a 'leg' on each side of the face typical of Senufo masks (PLATE VI, A).

Perhaps the most spectacular masks in the whole of African art are the large ones which are worn horizontally on the top of the head, which are found over a large area running along the coast from the Rivières du Sud, through Guinea, Portuguese Guinea, Sierra Leone and other territories to Nigeria. They combine human and crocodile or other animal forms, often with antelope horns attached, and in the Nigerian area at least are representations of the water spirits (PLATES IV and VI, c).

Turning to rather more naturalistic animal masks, we find that a belt

in which zoomorphic masks are found stretches across the Western Sudan art zone, including Northern Nigeria to the Cameroons. Although they are not over-stylized, it is not always easy to decide which animal they are meant to represent. They are occasionally Janus-headed (PLATE VI, B).

There would seem to be a basic type with a long flat face, short straight horns, human nose and eyes. This is possibly a buffalo or a bull.

This is changed by various stages into a ram, the forehead becoming larger in proportion to the lower portion of the face, the eyes larger and nose longer. The horns now curve. The mouth is sometimes opened showing bared teeth. Amongst many tribes the Sky god or Thunder is symbolized by a ram's head. The ram masks of the Dahomey and Yoruba are most realistic.

A rather different variant would appear to us more to resemble a dog or hyena; while another with long tushes suggests a wart-hog.

It is not easy to fix upon distinguishing tribal characteristics in these animal masks of the Western Sudan. Bird masks from the Ivory Coast tribes represent fairly naturalistically the hornbill.

In Northern Nigeria the animal masks with their bulging forehead and large curving horns, which are worn at an angle on the top of the head, would appear to represent more nearly a buffalo than anything else. But amongst the Jukun-speaking peoples, who spread over a large part of the area from which these masks come, a mask resembling a ram's head is commonly ascribed to the cult of Akuma, the creator. In this cult the masks are kept within a sacred enclosure, and set out on logs for food offerings and libations. In other districts the mask is regarded as the abode of some local ancestor, in others sometimes it represents a plurality of dead and gone chiefs. They are also worn by representatives of the dead at second burials and are used in initiation rites.

When we come to consider the work of the Western Sudan area in greater detail we find the ancestor figures of the Dogon are most impressive. Their figure carving consists in certain very old and very rare statues of single or pairs of figures of the ancestors or founders of tribe; these are brought out and placed by the bodies of the dead at burial ceremonies. Very stylized, these cult figures have a dignity which can only be compared with the early Egyptian carvings of the Pharaohs. They are some 70 cm. high, of hard wood which allows for finished detail; in some cases both face and body are heavily cicatrized. The pose is rigid and archaic, the figure usually being seated on a stool with the

hands, palms turned inwards, placed on the knees or thighs. The hair is sometimes crested, while a small beard or tuftlike ornament is pendent from the chin of both male and female figures. In the groups of double figures the male sits with his arm placed stiffly round the shoulder of the female. In the area of the chest, in addition to the breasts of the female figure being stylized in form, the chest in the male is carved as a rectangular box (PLATE VII).

In addition to these ancestor figures there are female fertility figures, which conform to the general schema, but are far less impressive than the burial carvings.

There have also been recorded certain figure carvings of a very different style. While the general build-up of the figures remains roughly the same, they are far more naturalistic and less stylized; and in one, a carving of a hermaphrodite sitting astride a legless animal, there is a strong feeling of action. The carvings have little detail, and the forms are presented as very simple rounded masses. (PLATE VIII, A, B.)

Dogon masks have about them something of the same statuesque, impersonal quality as their cult figures, for many of them are architectural rather than representational in form.

They are worn by members of the society *Nama* in miming dances at men's funerals, annual fête days, dances to procure rain, and other ceremonies. They are not treated with any particular care, but are thrown away when finished with or damaged. Certain rocky places become veritable mask cemeteries; such a place is Sanga in the district of Mopti where a large number of masks have been found.

The most commonly reported Dogon mask is roughly in the form of a tall rectangular box (PLATE VIII, c). In some the frontal plane below the brow is cut back in two parallel grooves separated by a ridge representing the nose which reaches the base. In others the frontal area, including brow and mouth, is divided into two diagonal planes meeting at the ridge of the nose. These rectangular masks are usually crested, in some cases with a tall female figure, in others by a double cross which would appear to be symbolic. Kjersmeier[1] calls this a crocodile mask, symbol of a Dogon legend in which, while escaping from their enemies, the people were carried across a river by a number of friendly crocodiles. Griaule,[2] however, says that it represents a bird, called the 'Spreader of wings of the bush' (PLATE VIII, D.)

[1] Kjersmeier, *Centres de Style de la Sculpture Nègre Africaine*, Vol. I, p. 21.
[2] Griaule, *Arts of the African Native*, No. 22.

Yet others of this type are surmounted by four horns, and bear some resemblance to the form of many horned masks used by other tribes of the zone.

The antelope crests of the Bambara are some of the most outstandingly lovely works of African art. They are worn attached to basketry helmets or caps, at dances in which the antelope is mimed during agrarian rites by young men of the *Chi Wara* Society. There are both male and female types, the female being generally smaller and less ornate, often carrying a young one on its back; while the male is represented with a mane which is developed into a perfect arabesque of graceful curves, the crest becoming almost an abstract pattern. In some pieces a human figure is carved in front of the horns. The crests are of soft wood, often reaching a height of between 50–100 cm. Of the many specimens in various museums no two are exactly alike, but all show the same extraordinarily sure sense of balance, curve responding to curve in perfect rhythm. Realism gives way completely to necessities of design; the antelope symbol is retained: but in it the neck or the horns of the animal may easily spring from the back or even from the tail; yet we have no sense of discomfort, simply because the artist himself has been so sure of his own aims. A pleasing texture is given to these carvings, which are of soft wood, by the use of incised patternwork over most of the surface (PLATES VIII, C, D, E and IX).

Neighbouring tribes use the antelope motif in a far more naturalistic form. From the Niger bend come crests in the form of naturalistic antelope heads, with long upright ears and straight horns, the whole crest being covered with painted geometric pattern; none of these, however, can bear comparison with the work of the Bambara, the grace of whose masks is the more remarkable when we consider the extremely square-cut stiffness of their figure carving. This consists of ancestor figures, fertility figures, and some very rare twin-figure carvings, and shows in the most pronounced form the characteristics of Western Sudan carving. Most marked is the stylization of the shoulder and breast area, and the reduction of the face to a few simple planes. The arms are usually short, with the palms held facing forward. These figures, with their archaic rigidity, accord most strangely with the graceful curves of the antelope masks (PLATE V, A).

The figure carving, consisting of fertility figures, of the Bobo is poor and uninteresting, and practically no pieces are recorded for study. Kjersmeier gives one carving which, except for the head, fits perfectly

into the scheme for Mali carving, which was collected by himself at Bobodioulassa, but which is of a type which Lem claims is strongly suggestive of the work of Mande craftsmen, and should perhaps be classed as Bambara.

The Bobo have several different types of mask. The first consists in a circular or oval face, almost completely flat, with stylized eyes in concentric circles, and diamond-shaped mouth with teeth, the whole being a mass of polychrome and carved geometric pattern. In most cases the mask is surmounted by a carved and painted plank crest, similar to those of the Mossi, but broader; the overall measurement is some 150–200 cm. high. These masks come from the region of Dioulasso, and are worn during the sowing and harvesting ceremonies (PLATE X).

The Bobo also have certain masks which might be considered alongside the large Baga *Banda* masks to be described later. In these Bobo masks the face is in the shape of an elongated pear, with a ridge running down the centre for a nose, and with two short horns or ears towards the back of the head, a plank crest being at the front. The crest is short and broad, the overall length being about 110 cm. The whole is decorated with geometric pattern, incised and in polychrome. These come from the Dioulasso area.

As with the Bobo, there seems little to be noted concerning the figure carving of the Mossi. One figure is recorded by Lem as collected by himself in the Yatenga. It conforms in general to the Western Sudan type, although except for the head it is rather less stylized, and the legs are considerably more in proportion. Female figures attached to the crests of certain Mossi masks are similarly long-legged and also stand with knees bent. The great interest of the first figure mentioned lies in the head, which is highly stylized and would seem to be a link between those of the Dogon and the Baga.

The masks of the Mossi are unique and very decorative. They consist in a head, which although slightly anthropomorphic is so completely stylized that it is practically abstract. In form it is in the shape of the bowl of a musical instrument; the 'nose' is represented by a ridge running down the centre of the front, and the 'eyes' by a triangular or circular hole close to it on either side. The mask is decorated with carved and polychrome pattern. From the front rise two slender antelope horns, curved if the mask is considered female, straight if it be male. Behind these is erected a long thin plank carved and painted in geometric design in the case of a male mask, and having a female figure attached in the

case of a female one. The overall length of these masks is about 200 cm. (PLATE XI).

Many pieces of Senufo sculpture show all the characteristics of the Western Sudan schema. The most marked difference lies in the roundness of all the forms: in this their work shows a marked kinship with that of the Baule and other tribes of the Guinea Coast area. The hair is carved in the form of a crest running from the back to the front of the head. Prognathism is much exaggerated, the face coming forward to a narrow point at the chin. The unity of the shoulder-breast area is not so marked as in the work of some other tribes of the area, the breasts of the female being very long, narrow, and pointed; the stomach also protrudes to a point at the navel. The arms are long, often very thin, ending in large flattened hands which appear attached to, rather than resting on, the thighs. The total effect of these Senufo figures is one of a rather curious forward thrust. The pointed chin, the breasts, the navel, and the pose of the lower arms and hands all contribute to this feeling. Certain of the figures reach a very high level, showing a great sense of rhythm in the relationship of their simplified forms (PLATE XII, A, B).

The third figure illustrated comes from the north of the Senufo's territory where the impact of the stronger, more rugged carving of surrounding tribes counterbalances the smooth sophistication stemming from Baule influence in the south (PLATE XII, c).

Certain Senufo carvings were originally fertility figures given to young girls at puberty, but now have become no more than children's toys; others, female figures concerned with the fertility of the soil, are placed in the fields by the young men during digging contests, or are carried by them during certain dances. There are also groups of 'twin' figures, described variously as 'made to give to twins' or 'for divination'.

The most often recorded type of Senufo mask is in technique and finish more like the work of the Baule in the Guinea area than that of the Western Sudan. The face is pear-shaped with delicately carved features and cicatrizations; the nose long, straight and very thin, with small square-cut nostrils at the base, and brows arching off from its root; the ears are represented by small square flaps; other flaps suggest hair; and two short 'legs' lead down from the side of the face between the ears and the chin. The head is surmounted by a crest often representing one or more hornbills. Both crest and side-flaps are decorated with incised cross-hatching; the masks may be Janus-headed. They are used by members of the *Lo* Society (PLATE XII, D).

Perhaps the most impressive sculptures in Africa are the great *Nimba* figures of the Baga. These great carvings are truely monumental, the features are near human in form, but transcendent, impassive and inscrutable. Nimba personifies fertility upon which all life depends, and at the time of the rice harvest appears raised high on the shoulders of its hidden wearer leading the tribespeople to a ritual dance (PLATE I).

Also impressive through their size and complexity are the *Banda* masks of the Baga and neighbouring tribes. These large masks, combining human and animal features, worn horizontally on the top of the head, have already been described in general terms. They are worn in the rites of their secret society *Simo*, and combine a stylized human face with sharp pointed nose and eyes, a jaw which is lengthened into a crocodile snout with teeth painted decoratively along the edge, a crest, and a pair of antelope horns. They are worn horizontally with a large fringe of fibre covering the body of the wearer, and are between 150–200 cm. in length. The whole mask is decorated with polychrome pattern, and is an extremely fine piece of work (PLATE VI, C).

THE SOUTH-WESTERN GUINEA COAST
(*The Mende, the Dan-Ngere tribes, the Gouro and the Baule*)

The work of the Mende shows the transition between the archaic stylization found in the Western Sudan and the more sophisticated and naturalistic forms of the central Guinea Coast. Their sculpture must be divided, not into separate tribal districts, but into two horizontal layers, probably representing successive cultures. Mention must first be made of the curious little figures (usually of soapstone) known as *nomoli*. These figures, some six inches high, consist of a very disproportionately large head, with large bulging eyes, enormous broad flat nose and lips, and jutting jaw. The figure sits or squats on the ground, both body and limbs being rather formless rounded masses. These figures appear to be relics of a past culture. They are found from time to time in the ground during cultivation, and are considered to have been made by God rather than man. They are given offerings of food, and also flogged ceremonially in order that they may bring a good rice harvest. They would usually appear to be male (PLATE XIII, A).

The Kissi nearby in Guinea also have steatite figures, some of which closely resemble the Mende *nomoli*.

An old wooden figure now in the British Museum, which is carved in

the *nomoli* style, would suggest that they cannot be of very great antiquity.

Modern Mende figure carvings, which are usually female, are called *minsereh* and are used for divination. They have no high artistic value, but are rather attractive. The hair is brushed up into a crest running from front to back of the head. The face is round with small features. The neck is long and carved as a succession of rings, which may represent wire spirals. The arms and legs are usually thin and long, the hands usually placed on the thighs, the feet standing slightly apart. The body often shows cicatrization (PLATE XIII, B).

Both the steatite *nomoli* figures and the *minsereh* escape from the rigid formalism of Western Sudan figure carving. The *nomoli* are usually carved in a sitting position, with their hands under their chins (incidentally a common position for the hands in Baga carving), and are rounded in form. The *minsereh* are more akin to Sudan work, but are more rounded and show more realization of proportion.

The masks of the Mende are more outstanding than their figure carving. They belong chiefly to the women's *Bundu* society.

The mask is helmet-shaped and comes right down over the whole head and face, and from it hang the heavy grass capes and skirts which completely hide the figure of the wearer.

The head, face and neck of the mask are considered as one solid whole, the hair on the head is dressed in an elaborate crest, the face is in the form of an inverted triangle, the forehead is a large, broad, flat dome, and the features are very compressed down in the pointed base. The triangular face fits flat against the neck, which as in the *minsereh* figures consists of a series of rings running round the back of the mask to above the level of the ear. This particular formal idiom is not found elsewhere in African art (PLATE XIII, C, D).

The Dan-Ngere complex of tribes on the Liberia-Ivory Coast border carve a wide range of masks which are again connected with the secret societies, chiefly *Poro*. They range from most aggressive abstractions, to the most sensitive realism. On the whole the first type seems to come mostly from the Ngere and the second from the Dan, but there is no hard and fast line of demarcation. They are extraordinarily powerful with a marked tendency towards cubism. They have a certain unity of expression, although they range from extreme realism to complete abstraction. For vivid realism the first mask illustrated would be difficult to beat. It is scarcely stylized at all, and the open mouth makes it very 'alive' (PLATE XIV, A).

Next comes a mask, still fairly naturalistic, but with the first sign of a formal idiom. In this there is a very marked change of plane between the forehead and the face below the brow; a ridge runs down the centre of the brow and nose; the eyes are narrow horizontal slits; the lips are large and very everted (PLATE XIV, B).

The next mask to be reproduced is anthropomorphic, but the treatment of the eyes as protruding cylinders, and the addition of carved tusks and horns curving across the brow, gives the mask a definitely bestial non-human appearance (PLATE XIV, C). Finally we show a mask which is completely abstract, with a number of horns curving across the 'face'. This is a fine and well-balanced rhythmic piece of work (PLATE XIV, D).

The art of the Baule of the Ivory Coast is highly interesting, not only because it reaches a very high standard of beauty, but because it shows so clearly the transitional stage in both thought and technique between the art of the Western Sudan and that of the more central art of the Guinea Coast.

The whole character of Baule carving is remote from the work of the Western Sudan. The figures are naturalistic and unstylized, yet they have a monumental quality which is of a very high order. Each figure has an air of dignity and reserve; they have style and elegance (PLATE XV).

The heads of the figure carvings are very much less stylized than those of their masks, and are very individual. They have drooping eyelids, a long flat nose, and hollow cheeks. The hair is brushed back into a crest. The form of the body is full and rounded. Both face and trunk are cicatrized. The arms are short, usually carved as part of the body, with the hands resting on the sides of the stomach. The lower leg is very short; the figures are usually standing with the feet slightly apart.

The completely anthropomorphic mask of the Baule is a very finished and sensitive piece of work. The face is usually in the shape of a long simple oval; the nose is long, narrow and straight, with small clear-cut nostrils at the tip, and branching at the root into a pair of strongly curving brows. Beneath these the eyes are carved with well-marked lids, especially the upper, the eye being often a horizontal slit through which the wearer can see. The mouth is small and shut. Sometimes a small, beard-like ornament is carved pendent from the chin, and the face is surrounded by a decorative carved band like a chinstrap. This would be associated, according to Kjersmeier,[1] with the secondary god Gou. The

Kjersmeier, *Centres de Styles de la Sculpture Nègre Africaine*, Vol. I, p. 31.

hair is brushed back into various forms of crest, or carved flat, when a crest consisting of a small figure or of bird-forms is placed above the head (PLATE XVI, A).

In technique the carving of the Baule area has an air of refinement and finish. It is often made of precious woods, highly polished and painted black, grey, and red.

The Baule carve personal portraits, both of notables and of others, while carving appears on many objects of everyday use such as drums, bobbins of looms, ladles, combs, staffs, and so on. It has been commented that the Baule enjoy art for art's sake, for not only do they fashion a large amount of secular and applied art, but they openly admire things of beauty. In an atmosphere where it has become natural to admire the beautiful, art may be expected to flourish and a high standard of finish and elegance may be attained, as is the case in this area.

The best work of the Gouro in the same stylistic area is extraordinarily similar to that of the Baule, yet it has certain distinguishing characteristics. The faces appear to be more pointed, the eyebrows are not attached to the nose, which tends to turn up and spread out into the nostril area without definite form, the eyes often rise diagonally outwards, the mouth is more expressive, and the whole expression gives more of a sense of movement than does the Baule work (PLATE XVI, B).

THE KINGDOMS OF THE CENTRAL GUINEA COAST
(Ashanti, Dahomey, Yoruba with Nok, Ife and Benin)

It is possible to work out a generalized description of the carving of the central Guinea area. The figure is conceived in terms of squat, rounded forms, combining both a knowledge of anatomy and an understanding of the necessity for subjecting this to the demands of sculpture; that is to say formal values are not lost in increased naturalism. These carvings no longer follow a set formula; they have individuality; they are carved in various positions, and often have a sense of movement or express a definite emotion. Elaborate and intricate groups are built up, comprised of a number of human figures and animals. The choice of subject matter, too, may be elaborate. Sculpture is not limited to the production of ancestor figures of one type or to fecundity symbols and masks; we now find carvings representing various gods and powers; and others, which seem purely secular, of men and women carrying out their different

occupations. There is a wide range of applied arts, too, for weaving and metal work, terra cotta groups, house and temple decorations in wood, bronze or colour; carved and decorated objects such as bobbins for looms, stools, food vessels, lamps, and so on, have their place amongst the possessions of those who can afford them.

The most easterly kingdom is that of Ashanti, whose artistic work is chiefly known through their ingenious little gold weights, which although charming to handle and pleasing in their wealth of representation of local proverbs, must be relegated to the class of collector's trifles (PLATE XVII, A); while the small fertility figures known as Akua Mma with their curious plate-like heads are of more real interest to the ethnologist than to the artist (PLATE XVII, B).

Elaborate and ornate art is almost bound to develop when it becomes an accepted sign of social prestige and wealth; and when art has won recognition in the palace a similar attitude will be reflected below. In the days of the Kingdom of Dahomey commoners were at one time forbidden the use of the work of the royal craftsmen, and later when the ban was no longer observed the common people could not afford to purchase it. Art was therefore still the privilege of the wealthy, and the craftsman's position in the community was assured.

The art of Dahomey is very closely related to that of Benin and Yoruba, both in its subject matter and in its form of expression, yet it is weaker and more superficial. Certain bronze castings, however, have life and vitality (PLATE XVII, C).

Much of the approach of Yoruba carving is in the direct tradition of that of Benin. The lively little genre figure carvings of everyday affairs, for instance — women weaving, holding food vessels or carrying water; men riding, carrying drums, smoking — having a strong resemblance to some of the little bronze figures, or the bronze plaques of earlier Benin work.

Some of the most sensitive work is found decorating the staffs of the Shongo priests, those illustrated here being particularly fine. In these we see strong naturalism coupled with a sense of sculptural form. The full rounded shapes show an observed appreciation of the beauty of the human figure, yet this is never allowed to dominate the instinctive sense of the balance of form required in sculpture (PLATE XVIII, A and B).

In highly decorative stools, drums and lamps, and also in the complicated figure compositions of the elaborate pillars of temples and

chiefs' houses, we see evidence of fertile imagination and a great sense of architectural design.

Yoruba figure carving shows certain very distinctive characteristics. The figures are lively and show great variety, every posture is attempted, and the trunk and body no longer remain on one axis. Forms are rounded, but are kept clear-cut and decisive; there is the usual African tendency towards enlarged heads and great reduction in the size of the legs. The form of the head is usually unmistakable; the general shape of the face is naturalistic, with pointed chin and large brow; the features are strongly marked. The eyes are long and pointed at each end, with the lower lid nearly as large as the upper, and the pupil of the eye is gouged out. The nose is broad at both root and base, with well-marked nostrils. The mouth protrudes, is thick-lipped, and does not narrow at the ends, which are slightly upturned. The ears are set high and well back on the head. Faces are cicatrized on the cheeks, and sometimes on the forehead, with tribal markings.

This rather sophisticated air of naturalism is seen clearly in a type of mask common to the *Egungun* and *Gelede* societies of the Yoruba. This mask is helmet-shaped, with a fairly naturalistic face. The hair is brushed back, usually to a crest running from back to front of the head. Sadler[1] states that the upper part of the mask represents a style of hair-dressing worn by married women (PLATE XVIII, c).

The masks are used at big public festivals, and the following quotations give some suggestion of the colour and life of the scene in which they play a part.

Murray[2] says: 'The Yoruba have a large number of religious cults whose members belong to them by right of birth or who have joined them on account of advice conveyed to them by divination. These societies have celebrations at yearly festivals and at funerals . . . among these is *Egungun* which is usually associated with the foundation of the town and is therefore performed to propitiate the ancestors and to promote its prosperity. During the festival the chief of the town does homage to the head *Egungun* who in return blesses him and the whole town.'

Talbot[3] says of the same society: 'the principal festival takes place just after that of the *Oro*, in June, when the crops are ripening in the farms, the first fruits begin to come in and the help of the dead is most needed

[1] Sadler, *Arts of West Africa*, p. 52.
[2] Murray, 'Masks and Headdresses of Nigeria', Exhibition Catalogue.
[3] Talbot, *The Peoples of Southern Nigeria*, p. 761.

... the images dressed in their long robes with a net or wooden mask over the face, parade the streets, jumping about, uttering sentences in an artificial voice and accompanied by friends who keep the bystanders at a distance with their long wands. They are treated with great respect; all who meet the procession prostrate themselves, and in olden days it was death to touch the *Egungun*'s dress.'

The *Gelede* Society is found among certain branches of the Yoruba, and holds similar ceremonies to the *Egungun* Society. The masks used are cap masks of the type shown in PLATE XVIII, C. They are made in pairs and are always female, whatever the sex of the deceased at whose burial they are used. They often have very elaborate and complex superstructures depicting the dead man or some legend. The entire body of the wearer is concealed by brightly coloured cloths, but he is not thought to be a spirit, and often carries his mask openly to the place of the dance.

In our general discussion of the special qualities which might be considered typical of Man-regarding Art, which I believe to be clearly exemplified in the art of these kingdoms of the Guinea Coast, we suggested that great elaboration might be expected. Throughout Southern Nigeria we find that elaborate three-dimensional design is attained by the building up of complicated figure groups. These groups are often found on headpieces or masks.

Some very fine masks of this type are used in the *Epa* festival at Omu in the south-east corner of Ilorin Province, Nigeria. *Epa* is the principal spirit of the Ora people of Omuaran village, and is supposed to have been a great carver who now guards his people. The mask is Janus-faced, shaped rather like an inverted cooking-pot, surmounted by a pedestal supporting a crest consisting of a single figure or a figure group of varying degrees of complexity. The mask itself is usually of a very simple stylized form, having a square rectangular opening for a mouth, and carved lozenge-shaped eyes, or sometimes very bulging eyes, a formalized nose and square cut base. The figure or group of figures on the crest is the larger and more important part of the mask, the whole being sometimes four foot high and two foot broad (PLATE XIX). The most simple crest may consist of one animal, Ekun, the leopard, Agbo, the ram, or Aja, the dog. Alternatively it may be more complex and represent either Odudua, the earth goddess or Olugun the warrior. Odudua will be represented usually surrounded by a number of children, one on her knees, one or more tied to her back, and several others grouped round her. Olugun is represented on horseback, and may be

surrounded by a group of children or a whole army of warriors, some-times arranged in several tiers. Even in the most complex of these groups each figure is conceived in the round and carved clear away at the back, an extraordinary technical feat when a complicated group is carved from one piece of wood. The best of the single figures of Odudua have a archaic formality which is impressive, and give a sense of massive strength, but the special quality of the work is most clearly shown in the complex groups where the large number of figures, in spite of being carved as separate entities, are yet conceived as part of one organic whole. In most cases the heads and upper portion of the trunk are on a large scale, the hair brushed upward into a decorated crest, the features large and stylized, the column of the neck vertical and long. The pieces are brightly painted in polychrome. There are many representations of Odudua, treated in this complex manner. Those from Southern Nigeria have the typical heavy-featured, rounded forms of the area, but those from the Afo in the north are of very great interest in that they attempt to combine the conception of the Odudua and children group of the south with the more simple figure formula of the north. In the resultant work the frontal planes of the face, the cylindrical neck and body, the square shoulders and forward pointing breasts are typical of the Western Sudan, but the complicated grouping, the attempted sense of movement and the more naturalistic sense of proportion mark its relationship to the work of the south (PLATE XX).

Northern Nigeria can rightly claim to be one of the most important sites in Africa for the art historian, for it is here that the growing col-lection of terra cottas of the Nok culture were discovered in the spoil heaps of the tin mines and first classified by Bernard Fagg some twenty-six years ago. Dating back to several hundred years before Christ many of these works in their balanced simplification of form are superb. They consist chiefly of heads remaining from whole figures which have dis-integrated over the passage of time (PLATE XXI).

Turning now to the sculpture of Ife we must now consider the unique collection of bronze and terra cotta heads found in the grounds of the royal palace (PLATE XXII).

One is immediately struck by the amazing difference between the form of these heads and other African work. They have a maturity and poise which at once suggest work of a highly developed stage of civiliza-tion. The best description of their most unusual qualities is given by Underwood in his interesting analysis of the difference between what he

calls the Pre-classical (or normal style of African carving) and Classical, or Ife work. 'The frontier between classical and pre-classical styles is well marked by what we may here call intellectual vision. What it amounts to is that at this point the intellect interposes a filter in the conscious mind, through which the eye perceives objective nature. That is to say, henceforth, the artist drawing from nature does so by a conscious intellectual effort which cultivates his judgement of relative measurements and proportions.

'When the visual image is seen through the intellectual filter of comparative measurements, the image drawn by the artist is to be compared with that of nature. . . . This intellectual filter of the vision marks the difference between romantic and classical art. The child, the romantic, and the ancient or pre-classical artist, see things not in proportion to their measurements but in proportion to their subjective meaning. Expression of the primitive and the romantic artist, is intensive not extensive — simple and direct. Anything which might be added to their intensive vision by relative measurement would only weaken and obscure its expression.'

In this connection, of course, Underwood's meaning of 'classical' is entirely different from the sense in which it is used in the title of this book. There it designates all that has reached a sufficient standard in the great range of African art before it came fully under the influence of Western civilization; Underwood, however, uses it to denote a relationship in ideas with classic Greek art.

The point which he makes is of great importance. Child art, primitive art, and peasant art is an emotional, a felt expression; sophisticated art is intellectualized and observed. In Greek classical art an idealized human type was created through intellectual effort, and the art of Ife has just this sense of intellectual striving after idealized form which is remarkably different from anything we see elsewhere in Africa. It is no early fumbling of awakening powers of observation, but a full-grown grasp of proportion and form. The soft fullness of the flesh is expressed with great subtlety, and although each head conforms to a very distinct style there is enough differentiation to suggest portraiture. This sculpture of Ife is one of the great mysteries of art history. It is provisionally dated as about the thirteenth and fourteenth centuries A.D., giving a complete break of a thousand years from the sculpture of Nok dated between 500 B.C. and A.D. 200; yet no intermediate work has so far been discovered. There are some very interesting similarities between the two

especially in the fragments which have been found of limbs and bodies; and in the modelling of nearly life-sized figures, an accomplishment which was not attempted in any other part of Africa as far as we know at present. But the character of the head carvings are sharply differentiated, those of Nok being usually as strongly stylized as those of Ife are naturalistic.

The art of the royal court of Benin has to be considered apart from the everyday art of the Bini people as a whole. For this highly specialized art was closely associated with that of Ife as, in about A.D. 1400, the Oba of Benin is said to have sent to Ife for a bronze founder to teach his royal craftsmen to cast in metal. The normal carving of the Bini was highly conceptual in character, so that the influence of the very naturalistic approach of the work of Ife must have caused something of an artistic revolution in the art of the court craftsmen. This can be seen in the less than life-size thinly cast heads of the early period, usually dated about 1500, which show a very naturalistic approach. Slightly later may come the beautiful sensitive and naturalistic queen mother heads wearing a hornlike headdress; and then, probably at the end of this early period in the mid-sixteenth century, some very powerful heads of marked prognathism (PLATE XXIII).

The prolific middle period of Benin court art, that of the middle sixteenth to the late seventeenth centuries, seem to have been made feasible by the importation by the Portuguese of tin bronze in quantity from Europe. It was now possible to cast the hundreds of heavy bronze plaques which covered the pillars of the palace in the seventeenth century. Many of these have an air of mass production, of works commissioned wholesale from competent but uninspired official craftsmen to cover a specified area. Nevertheless it is possible to pick out from among them the work of individual artists such as the one whom William Fagg has styled 'the master of the leopard hunt'. This artist abandoned the heavy formalized compositions of his contemporaries and built up in their place panels bestarred with delicate foliage and with huntsmen and their quarry arranged in a convincing manner yet free from the requirements of normal perspective. The result is a refreshing series of very beautiful unsophisticated decorative panels (PLATE XXIV).

The plenitude of material is seen too in the thickening of the casting used in the production of heads. By the beginning of the eighteenth century these heads were being used to support large carved elephant tusks and therefore had to have the required strength and balance for the

task; and once again material rather than aesthetic considerations tended towards stereotyped productions in a large number of cases. Finally in the late period the heads degenerated into a kind of baroque over-decoration with a lack of subtlety in the modelling of the features, almost a caricature of the beautiful work of the earlier court artists. The fusion of two different artistic cultures is by no means an easy matter, and perhaps this somewhat uninspired realism was a not surprising result of the attempt of the Benin craftsmen to put on one side their own spontaneous way of approach and adopt instead the sensitive naturalism of Ife. That they were capable of producing works of art of great sensitivity of a conceptual rather than a naturalistic character can be seen in a small group of heads which may well have belonged to a spirit cult within the palace (PLATE XXV).

There remains a group of bronzes collected together by William Fagg during recent years as being untypical of the main body of Benin work, but which on further study revealed a unity of their own. At present little can be said with any authority as to their provenance or date, nor indeed have all the bronzes sufficient family likeness to be attributed with any certainty to a common source, although it would seem probable that they all originate in the Lower Niger area between the Delta and the confluence of the Benue and Niger rivers. They have been tentatively called the Lower Nigeria bronze industry. They include the large bronzes of human and animal figures found at Jebba and Tada on the Middle Niger but reputed by legend to have been brought from the Lower Niger in the early sixteenth century. One of these has all the marks of an Ife master, the rest are related by style or iconography to the art of Benin. Still others come from Igbo-Ukwu near Awka. It is difficult to define any single quality linking these very diverse pieces of sculpture together beyond these vague connections. Possibly work was commissioned by the royal centres from tribal craftsmen further down the river, or alternatively they may have been made by craftsmen from the riverine tribes who had travelled to these cities and worked there. The seated figure of Tada, so impressive in its naturalism, and the magnificent bronze huntsman, are poles apart but one thing must be said of them, they are each in their own way superb works of art. The first is visualized, the second felt by their respective creators, but both have been conceived with the same sensitive understanding. The huntsman together with others of a similar genre and the Benin head (PLATE XXV, c) have an exciting, moving beauty very different from works

made for court prestige and should be classed as Spirit-regarding. Some of these bronzes can undoubtedly be reckoned among the really great examples of African art, and it is hoped that in the not too distant future a great deal more will be known about them (PLATE XXVI).

THE EASTERN FOREST BELT OF THE GUINEA COAST
(The Ijo, Ibo, Ibibio and Cross River tribes)

Our cursory outline of the story of the occupation of the Guinea Coast and the Western Sudan by its present inhabitants led us to consider in passing the more primitive tribes cut off in the dense forests of the coast; and we noted that it was here, where there was no strong and wide-spread monarchy with which to compete, that the secret society was often all-powerful, and its authority was upheld by dancing and ritual in which the terrorization of non-initiates held a large place. So we find the mask in its most expressive and dramatic form, sometimes striking terror by the association of its subject matter — skulls and snakes or faces suffering from terrible deformities; sometimes by the material of which it was composed — the skin of the head of a slaughtered enemy; sometimes by the sheer force of its physical form.

Not all these masks were aimed at producing fear, that was only one aspect; the societies developed festivals and annual plays which were also times of rejoicing and mirth, and the masks were noteworthy for their sense of beauty. Among the Ibo, for instance, masks are often carved to portray beautiful spirit maidens. The influence of neighbouring tribes, where the values of social prestige are strongly expressed in artistic form, will also come in; and finally we shall find that certain types of mask cannot be confined to any one region, and through them modes of expression have spread across hundreds of miles of country and many tribal areas. The elaborately built-up figure groups, which are used as headpieces and for other purposes by the Yoruba, are also found amongst the work of the Ijo and the Ibo. The Ibo figures, known as *Ikenga*, often consist of highly complicated carvings of this type; they are the personal protectors of the master of the house and are consulted in every family crisis (PLATE XXVII, A).

Then come the more simple head-pieces worn for *Ogbom* in the Bende and Aba divisions of the Owerri Province of Southern Nigeria. *Ogbom* was a play held in honour of the earth deity, Ala, and was believed to

make children plentiful. Everyone joined in the dances, but the head-dresses were only worn by the men, who made no attempt to conceal their identity or pose as supernatural beings. The play was abandoned some fifty years ago except in a few villages, so that *Ogbom* carvings are of some antiquity. They consist of large female figures, sitting or stand-ing, usually having some object held on top of the head. They are far more archaic in style than Yoruba carving of somewhat similar type, and the best of them are fine pieces of work (PLATE XXVII, C).

In our account of the masks of the Western Sudan we have mentioned large horizontal masks with mixed animal and human features reduced to an almost abstract pattern. Masks of this type are also found in their own characteristic forms among the Yoruba, the Ijo, and Ibo, and other tribes of the coast and lagoon areas. We show two zoomorphic masks of this type which come from the Niger delta. The first is of the *Obukele* Society of the Abua, the second belongs to the Ekkpahia Ibo. These masks approach very nearly to the abstract, the eyes and ridge of the nose being absorbed into the curvilinear pattern of the box-shaped head. They are large and heavy, in good proportion, and give a general effect of massive strength (PLATE XXVIII, A, D). Among the Ijo the *Sakapu* is the most important secret society, which ruled the country before the arrival of the British Government. The members performed a most elaborate system of plays in honour of the Owu or water spirits. After sacrifices, with feasting and dancing, the Owu are asked to come forth from their home under the sea and to be present at the rites. The head-dresses are said to represent the Owu when they were last seen. A splendid horizontal mask is shown as worn in Plate IV.

The Ibo *Obukele* is also a cult of the water spirits, adopted in imita-tion of the *Sakapu*. Their chief celebrations take place when the rivers are full, and the spirits are prayed to for health and fertility. Other Ijo masks also worn horizontally, in which the combination of animal and human forms is clear, exist; in these the human face, not too remotely stylized, is felt as a whole resting on a horizontal platform which lengthens into a flattened horn shape at the top, and a long animal mouth at the bottom (PLATE XXVIII, C).

The explanation that the Yoruba, Ibo and Ijo masks are portraits of the spirits as seen floating in the water, and the suggestive resemblance in some to the form of a hippopotamus and in others to a crocodile is interesting. In the mythologies of all coastal areas of the Guinea Coast water spirits play a large part, and there are references to the spirits of

the dead coming back from the sea, or ceremonials wherein the dead are buried in the sea.

Further inland, where the large horizontal zoomorphic mask is found, it often seems to conform more to a bird type than a hippo or crocodile form. Horizontal masks combining human and animal or bird features are used by the Ibo in the South-west of Onitsha Province. They may have adopted the type from the Ijo, as the horizontal mask is otherwise unknown among the Ibo, beyond those in the Degama district quoted above.

These masks from Onitsha Province are of two kinds; one has a beak that is almost certainly a bird's; the other an elongated rectangular snout that might be bird, beast or fish. There is no suggestion that they represent water spirits, as they are worn by members of the *Mmo* Society (PLATE XXVIII, B).

In the Guinea area masks of a markedly abstract form are not as common as in the Western Sudan. Apart from the large horizontal mask containing both human and animal features of a very abstract type, this quality is best seen in the mask *Maji* worn in a play performed at the final stage of the initiation ceremonies by the Ibo of Afikpo District, Ogoja Province, in Nigeria. It is described as a terrifying mask with human eyes, a sword coming out of the forehead and three conical projections beneath it, the whole suggesting vaguely the prow of a Melanesian war canoe. The sword is said to represent the special knife used to cut yams at the New Yam festivals and the projecting snouts are said to be teeth. The mask is sewn to a woollen cap which holds it rather high in front of the face (PLATE XXIX).

The *Ekpo Njawhaw* Society of the Ibo and Ibibio has been quoted as an example of the more unpleasant forms of secret society in Eastern Nigeria. The Ibibio masks used by this society are excellent examples of the African's power of expressing sinister qualities in his carving.

The characteristics of this type of mask are well marked. The large ears are carved separately and hinged on to the head; they are sometimes made of hide instead of wood; in many cases they have subsidiary heads carved on them. In the face and head as a whole the horizontals are strongly marked; sometimes by the brows, eyelids, cheekbones, and mouth being represented by overhanging flounces somewhat like the scales of a fish. In others the cheeks and forehead are bulbous, approaching the forms found in the Cameroons. The teeth are prominent; sometimes a protruding tongue is carved. In some the mask supports a shelf

on which are placed skulls, figures, and so on. While a number of masks of this type are identified as belonging to the *Ekpo Njawhaw* Society, others are referred to as being similar to those made by the Anang for the *Ekpo* Society, and one is identified as an *Ekong* mask. The general impression given by these black masks with their skulls, snakes, and bared teeth, is of a heavy coarse brutality. They are tremendously strong and convey a great sense of evil (PLATE XXX, A).

The 'Deformity' masks of the Ibibio are equally unpleasant. Masks which show the various manifestations of tertiary yaws are common. These horrible representations of abnormalities are said by Murray to be used by the *Ekpo* Society. They are clever pieces of work, brutal, and leave little to the imagination (PLATE XXX, B).

The most noticeable general characteristic of the masks of the Ibo is their extreme refinement and delicacy, compared with so much of the work of other African tribes. This sense of refinement is often produced by the small size of the masks, with their thin sharp features. They are often painted white, and have the hair and tribal markings on the face picked out in black or colour in a very decorative fashion. A large number of them are said to represent maiden spirits or beautiful girls; these are often set in contrast with other ugly elephant spirits, or mischievous he-goats who chase small boys, and so on. In all these we find a definite attempt to convey, in some cases an idealized type of ethereal beauty, in others an expression of aggressive fierceness (PLATE XXXI, A and C).

Many of the masks used by the Ibo *Mmo* Society are of this maiden spirit type. They are of two kinds. The larger one has a thin high crest, running from back to front of the head; this crest is highly ornamented with fretted carving. The top of the mask is carved as a cap shape to fit over the head, while the face is long and triangular. The face is whitened and has black- or blue-lined brows, eyes and lips. To us the thin lips present a somewhat cynical appearance (PLATE XXXI, B). The style of hair-dressing of these masks is that of the women of Awka, Onitsha Province, but very similar specimens from the Thomas collection in the Cambridge University Museum are labelled Fuga and Agenebode, both from the northern part of Benin Province; while it is interesting to note that some late period Benin bronze heads wear a helmet with a very similar crest.

The second kind of mask representing the maiden spirits in the dance of the *Mmo* Society is much smaller. It fits in front of the face and has

F
81

no head cover. It has a thin, fine-cut nose, with very delicate patterning on the forehead, temples, cheeks, and corners of the mouth (PLATE XXXI, A).

Talbot,[1] writing of the uses of these masks, says: 'The images are entirely covered by voluminous clothes, the upper part often composed of some knitted material. Occasionally a sort of kilt is worn, but the legs are always hidden by cloth or knitted trousers. A wooden mask is used, which is at times placed on top of the man's head so as to give him increased height, while he himself looks out through narrow slits below. Nearly all masks are painted white, like the clay statues of ancestors in the Mbari houses, and some are of very great interest and display un-doubted Egyptian traits.' Of one of the Society's dances, *Ayolugbe*, Murray[2] says: 'three to seven white-faced masks are used: they represent the spirits of maidens with their mother, and have dignity and beauty. The masks are "made to measure", and with them is worn a tight-fitting costume of gorgeous colour decorated with appliqué work in which red and yellow predominate. These masks of small size are sewn to the costume and are surmounted by a fantastic, brightly coloured cane superstructure.'

The Ibo of Orlu and Ahoada in Owerri Province have a play called *Okorosia* which is similar to the *Mmo* plays in Onitsha, and in which similar white-faced masks are used. These masks have a very sinister expression, for the mouths are often stretched and twisted (PLATE XXXII, B).

The masks of the *Igojji* society or *Iko Okochi* of Afikpo are not so finely cut as the previous ones, but seem to have some affinity with them. Those with 'plank' crests should be compared with those of the Mossi and Bobo of the Western Sudan. A description of the harvest festival of this society is taken from Murray.[3] 'The *Iko Okochi* festival is a celebra-tion of rejoicing and thanks-giving at the end of harvest. During this time various plays with their special masks are performed by men and youths who have concluded their initiation. They can freely choose what play they perform, and they often carve their own masks; but there are traditional forms for the masks and for the method in which they are used. Some represent girls and are used in a kind of ballet in pairs, one of which represents the girl who is being shown her behaviour. They

[1] Talbot, *The Peoples of Southern Nigeria*, Vol. 3, p. 768.
[2] Murray, 'Masks and Headdresses of Nigeria', Exhibition Catalogue.
[3] Ibid.

are worn with a ruff of feathers round the face. The decorations carved from eye to jaw are jokingly described as tears because the wearer can see no one to beat!'

Then come the *Elu* masks of the Ogoni tribe. Murray[1] writes: 'The Ogoni tribe of Rivers Province have numerous societies with social, religious and governmental functions, that use masks at their club meetings, the annual festivals, or funerals of members. Societies based on age-groups, which might be called of junior grade, as their purpose is chiefly social, use masks called *Elu*. These, which in spite of their small size are worn by adult men, are hung in front of the face fitted to a conical cap of raffia and cloth which covers the shoulders. Ordinary clothes, singlets and coloured printed cloths, are worn with them, sometimes with a raffia ruff tied round the waist. By permission of the senior grades, the junior may have masks with mouths that open and shut. These are manipulated by the lip of the wearer working in a groove cut in the lower jaw so that the lips of the mask shut together noisily. Performances vary, sometimes the players stand behind a curtain and sing with their heads and shoulders showing, while the audience, celebrating a deceased member, chat and drink as if in a restaurant.'

These masks with hinged jaws are very ingenious. The lower jaw is carefully cut to fit, and fixed with a piece of fibre. The teeth consist of a large number of pieces of stiff cane two or three inches long, fixed in both the top and bottom jaws, so that when the mouth is open it presents an amusingly formidable appearance. For the rest, the masks are in much the same fine-featured, white-faced style as those previously discussed (PLATE XXXII, A).

A fairly naturalistic type of mask is used by the Ogoni; apparently by several societies, including those mentioned above. Although they do not seem to attempt to be particularly fear-inspiring, they cannot be considered attractive. The mouths are represented as open with the teeth showing; small ears are carved sticking out at right angles to the head, which is itself surmounted by a caplike form. Although the most spectacular work of the Ibibio consists of these strongly expressive masks, other carvings are of value. (PLATE XXXII, A.)

From Oron, in Calabar Province, comes a very fine and unusual collection of carvings of 'the elders' with plaited beards. These carvings are of a totally different style from other Ibibio work. Their general schema is the same throughout — an archaic figure, facing forwards, the hands

[1] Murray, 'Masks and Headdresses of Nigeria', Exhibition Catalogue.

folded across the top of the stomach, often supporting a couple of smaller figures, very short legs, the head usually crowned with a species of hat, each figure having a long plaited or curled and twisted beard. There is tremendous variation in the treatment of the face and features of each carving. Many of them are of high aesthetic value apart from their unusual form. They could profitably be compared with the Dogon ancestor figures of the Western Sudan (PLATE XXVII, B).

Among the semi-Bantu tribes of the Cross River area the most important are the Efik and Ekoi. These people show very distinct characteristics in their masks.

These masks, which are made of wood covered with skin, are slightly larger than life size. They are often two or even three-faced. Talbot says of this Janus-faced type that the two-faced mask represents the omniscience of the Deity looking both ways; into the future and back into the past; also the bi-sexual character shown in the oldest representations of Obassi Osaw and Onassi Nsi, sky-father and earth-mother (PLATE XXXIII, B).

These skin-covered masks show very distinctive characteristics. The heads are long, with high foreheads and pointed chins; the noses are thin and there is a clean-cut appearance about them. The mouths are open, showing the teeth. The clean-cut, fined-down type attracts attention; in most cases they have a dignified simplicity. The head is carved in soft wood and covered with skin, often human; leaving bare the horns or crest, eyes and mouth. The eyes are of metal or of hard wood plugs. The teeth are of cane. The hair, eyebrows and tribal markings on the face are of a dark stain. They would seem to have originated in the custom of members of head-hunting tribes of wearing the dried heads of their enemies during war dances. Talbot[1] says: 'when the enemies' heads were brought back, they were put in water, cleaned and dried, and worn on top of the dancing head-dress,' and also 'In most of the "plays", especially among the semi-Bantu, head-dresses are worn consisting either of real skulls, or of wooden imitations, sometimes covered with human skin'. Antelope skin is sometimes used as a substitute (PLATE XXXIII, A).

A number of these skin-covered masks have enormous spiral horns, often three or more in number, rising from their heads (PLATE XXXIII, C); they are worn by members of various secular societies in a dance which is played at funerals and at other ceremonies, and at festivals such as Christmas, when the members accompany the masked

[1] Talbot, *The Peoples of Southern Nigeria*, Vol. 3, p. 850.

figures — usually two — from house to house. The headdresses are meant to be impressive and to enhance the prestige of the society. An identical one is given as Ibibio (Ikot Ekpene district), where it is used in a secular play in honour of girls when leaving the fattening house.

THE CAMEROON GRASSLANDS
(The Bamum and Bali tribes)

The Bamum, situated on the Num plateau between the rivers Num and Mbam, with Fumban as their capital, are the most important tribe artistically. Their late king, Njoya, was a remarkable man, who reduced the language to writing, built large palaces, and made a museum of his people's crafts. Much of this work is secular, and consists of stools, door-frames, drums, boxes, pillars, pipes, and so on. Much of the best craftwork is associated with the royal household.

Another tribe with a reputation for good craftsmanship is the Bali, whose pipes in the genre of our own old Toby jugs are famous. In reality these pipes are as often as not made by the Bamum, Bamassing or other tribes, for the art of the whole area is extraordinarily homogeneous and, although actual craftsmanship is kept within families and handed down from father to son, it is traded over a wide area.

The figure carving of the Cameroon tribes has a crude naturalism and vitality which is strong and impressive. They often show men seated on a stool, with a calabash of beer in one hand, the other resting on the knee. The figures are well-proportioned and broad-shouldered, with knees wide apart, and feet and hands only sketchily attempted; strings of beads are suggested round the neck; the hair is caplike and marked with deep cross-hatched incisions. The eyes are large pointed ovals with a parallel ring representing top and lower lids, the mouth is large and pointed at the corners, having its lips drawn back to show serrated teeth (PLATE XXXIV, B).

This would seem to be a peasant art with an appeal for the common people, portraying ordinary people for their own enjoyment.

The masks of the Cameroons show similar characteristics to their figure carving. A common mask is in the form of a fairly naturalistic, though roughly carved, head. The forms are considerably rounded, deep hollows dividing the lower curve of the cheek from the section containing the mouth and chin. The width of the eyelid ring is the same all round the eyes; the wings of the nose are emphasized, meeting in a

point at the tip. The mouth is usually in the shape of a double bow; the lips are thin and not emphasized, but drawn back showing serrated rows of teeth. The ears are small and round, and set as high or higher than the eyes at right angles to the head. The hair or head dress is high, and sometimes takes the form of a lattice-work pattern, as noted in stool and pipe work (PLATE XXXV, B).

Masks with greatly exaggerated bulbous forms are also common. The cheeks protrude like tennis balls or are pendulous; the form of the mouth is much the same as in the mask described above; the nostrils are more exaggerated, leaving a sharp ridge down the centre of the nose; the eyes are often round, and may protrude as cylindrical forms; the ears are very small, standing out at right angles from the head. The head-dress may be in the form of a flat cap, often surmounted by an animal or built up in a lattice-work effect (PLATE XXXV, A).

These masks are larger than life-size and are worn with the lower border resting on the shoulders.

The animal masks of the Cameroons have the same air of cheerful buffoonery and good humour as many of their anthropomorphic masks and figure carvings.

Large ceremonial earthenware pipes are carved either as whole figures or heads alone. When the whole figure is represented, the head together with the headdress will equal or exceed in size the body. The figure is seated, the lower half of the body and legs are extremely small; the arms are usually carved in one with the body, with the hands on the knees or stomach, or sometimes supporting the chin. The feet are only roughly indicated. When the head is carved alone the head dress may be built up as a tall cylindrical tower; sometimes two tiers of heads are used, at other times the head dress is shaped as a convex half-moon decorated with pattern. The work is often clumsily carved and is done when the clay is leather-hard (PLATE XXXIV, A).

Stools and bowls are commonly carved with a number of human or animal caryatid figures. These figures, sometimes in two tiers, are often so arranged that legs, arms or ears form an irregular pattern giving a diamond lattice-work effect. This motif and treatment can also be found on head dresses.

Other Cameroon animal carvings, where the animal is not arranged to give this diamond-shaped effect, have a peculiar horizontal stance emphasized by the line of the throat and chin continuing that of the belly. Certain stools and masks are decorated with beadwork.

THE SOUTHERN CAMEROONS AND THE GABON
(*The Duala, the Fang, the Bakota, the Mpongwe and the Bakwele*)

On the coast of the Cameroons the Duala, a tribe of traders and sea-men, seem to have achieved a synthesis of European and African technique and thought which has created a new art form of real value. Their carved prow heads, and other objects in which an arabesque of human and animal forms is built up in brightly coloured profusion, are master-pieces of real beauty (PLATE XXXVI).

The figure carvings of the Fang are said not to be definite representations of the ancestors, nor the abode of the spirits, but are figures placed on large containers made of bark or basketry, to hold the bones of the departed. They consist chiefly of heads on long necks; there are also half-figures, and complete figures on pedestals. These carvings are some of the most beautiful in Africa. Simple, oval faces with rounded foreheads, flattened cheek bones and pointed chin give a wonderful line, while the suggestion of long straight hair emphasizes the form. They have a restful sense of dignity and melancholy peace. In the complete figure the lower part of the body is shortened, the knees bent in both sitting and standing positions, the limbs very rounded, while the hands are usually clasped in front of the body (PLATES XXXVII and XXXVIII).

The Bakota use figures as guardians of the bones in a similar way to the Fang. But whereas the latter have developed a style of idealized naturalism, the Bakota work turns to a style that is decorative and almost abstract. Their guardians consist in flat wooden forms covered with sheets of metal or brass. The face of the figure is represented as a flat oval plane, with stylized representation of eyes and nose, but often no mouth; while the cheeks and temples are decorated with repoussé pattern. Two further flat planes represent the ears, and above the head a moon-shape crest is affixed. The body is usually in the form of an open diamond. The whole effect is a very fine piece of decoration (PLATE XXXVIII, A and B).

The tribes of the Ogowe area in the south of the Gabon such as the Mpongwe, Ashira and Balumbo produce an interesting and rather beautiful type of mask. This fits over the face and has moon-shaped slits for the eyes. The face is gently rounded, and the nose long and well-formed. An elaborate style of hairdressing is carved above the face. The

hair is painted black, the face white; the mouth is picked out in vivid scarlet, and the eyebrows drawn as a fine line in black.

The total effect is extraordinarily reminiscent of the work of eastern Asia (PLATE XXXIX, c).

Another most interesting type of mask is heart-shaped, and can be found in tribal carving stretching across Africa from the coastal Fang in the Gabon to the Bambole and Balega in the extreme east of the Congo. It is illustrated here by a mask from the Bakwele (PLATE XXXIX, D).

THE CONGO

While it is easy to state in general terms that the art of the Western Sudan would appear to be Spirit-regarding, because here we find many ancestor and fertility figures; and that in the Guinea area the preponderance of topical secular subjects treated in sculpture, together with the finer finish, sense of form and regard for design, can be explained to a great extent by the human prestige value given to art in that area; it is not so simple to make wide sweeping generalizations for the Congo zone. Art there has been described as a fine balance between the naturalistic and the decorative, and at first sight our theories seem to lead us nowhere. But it is clear that, in both the Bakuba and Baluba areas, as also in the Lower Congo, art has a value beyond a Spirit-regarding or magico-utilitarian one, and this is reflected in both ancestor figures and masks.

THE LOWER CONGO
(The Congo-Kwango area)

The most notable carvings of the Lower Congo area are those of the Mother and Child motif. In these the mother is usually seated cross-legged, with the child lying across her knees, although often other positions are attempted, and even in the more formal position the carvings have a sense of vitality; the body leans slightly forward, with the head tilting back. The body of the mother is heavily tattooed.

It is interesting to compare these carvings with those of Odudua and her child, or children, of Nigeria. The Congo ones show great vigour, and often naturalism, but in spite of this they fail to express the intimate relationship between mother and child which is felt in the groups of both northern and southern Nigeria (PLATE XL, A).

The other common motif in the Lower Congo is the 'medicine-containing' figure often thickly studded with nails. These figures attempt movement: for example many of them brandish a knife in an uplifted arm. The heads are tilted back, and the features are clear-cut with prominent cheekbones, thick lips and pointed teeth. Often the eyes and the medicine-containing chamber hollowed out of the stomach are inlaid with fragments of mirror. Many of the figures are so thickly studded with nails hammered in by those seeking aid of the fetich that they lose all interest as sculpture (PLATE XL, C).

THE LOWER CONGO
(The Kwango-Kasai area. The Bambala, Bayaka and Bapende tribes)

The Bambala, who inhabit the north of this area, produce fairly large figure carvings. These commonly represent either the mother and child motif, or a musician playing one of several types of instrument. The carvings are notable for their lack of symmetry and sense of action, the musicians especially are far less formalized than most African carving and remind us of the genre carving of the Yoruba (PLATE XLI, A and B).

Amongst the Bayaka, a people who live on the east bank of the Kwango, masks are practically all connected with initiation ceremonies. The lads who go through these ceremonies live apart in specially constructed villages in the bush, and at the end of their period of initiation take part in a grand finale of dances which are performed in the villages far and wide. The masks which are worn during these celebrations are made by specialist craftsmen, and are worn by the leaders of the dance.

The masks are of a pull-on type with great masses of fibre hanging around them. The face is extremely stylized, often surrounded by a raised circle of wood, or the eyes themselves may be formed by such circles. Even when a raised circle of wood is absent the circular form is usually painted on. The nose is a peculiar upturned snout. The top of the head takes various forms: it is often tall and conical, surrounded at various heights by rings resembling hat-brims or haloes. The masks are painted in polychrome (PLATE XLI, D).

One very different type of mask is worn, according to some authorities, by the master of the ceremonies; it is housed in the enclosure of the initiates and is supposed to have special magical properties. This mask is very large, up to two or three feet in height, it is fairly naturalistic

with enormous apple cheeks and large lidded eyes. It may owe its very different form to the influence of neighbouring tribes, or to earlier intrusions of a different people (PLATE XLI, c).

The Bayaka also produce curious little figures which are unique to themselves. The carvings are oddly shaped with large retroussé noses, arms carved as a whole with the body, hands upon the stomach, knees slightly bent, the whole having a curious restless, lumpy appearance.

The masks of the Bapende, like those of the neighbouring Bayaka, are chiefly connected with circumcision and initiation ceremonies. The faces are not overstylized, the foreheads bulge, and the curved line of the eyebrows stretches right across the face. The upper lids droop over the eyes, the cheekbones are prominent, and the lower portion of the face forms a long triangle; the nose is sharply pointed and cut in a flat plane below the tip; the corners of the mouth turn down. The face is sometimes decorated with incised pattern; the back of the head is covered with a fibre wig, while raffia or woven cloth hangs from the chin (PLATE XLII, A). Similar in form to the true masks are tiny masks carved in ivory, which are very beautiful and delicate.

The Bahuana and Basuku also carve sculpture of merit.

THE BAKUBA
(The Bakuba, Bena-lulua and Dengese tribes)

The most outstanding work of the Bakuba is a series of royal portrait statues, nine of which have found their way to the museums of Europe and Great Britain. These small carvings — they average about 50 cm. in height — are very fine. They are stylized rather in the manner of early Egyptian royal portraits; each king sits cross-legged on a pedestal; a heavy, squat, immobile figure with a large head and impassive face, having its heavy-lidded eyes half closed; in front of each pedestal stands some emblem symbolic of the particular attributes or interests of the king who is represented.

The first is Shamba Bolongongo himself (1600–20), and represents him sitting (according to Torday, who acquired the carving for the British Museum) before a 'lela' board (the game common to a large part of Africa) (PLATE XLIII, A). Next comes Bom Bosch, who reigned about 1650; and after him Misha Pelenge, dated about 1780 (PLATE XLIII, B). He is followed by Bope Pelenge towards the end of the

eighteenth century, who, again according to Torday, is seated before an anvil showing his proficiency as a blacksmith (PLATE XLIII, C). After him comes Kata Mbula, and then Mikope Mbula, who reigned between 1810–40. Mikope Mbula is said to have fallen in love with a slave girl, and in order to marry her revoked the law that a freeman may not marry a slave. This romantic episode is commemorated by the carving of the little slave girl in front of his statue. This last statue is more naturalistic in its proportions than the earlier ones, the lower part of the body being approximately on the same scale as the upper, but it certainly does not gain in dignity by this. Finally come Bope Kena, 1840–95 (PLATE XLIII, D), and Kwete Mobindji about 1928.

There is another statue, possibly of Mikope Mbula or Bope Mobindji, in which the length of the torso restores some sense of the monumental in spite of considerable naturalism, but the earlier work is undoubtedly far the greater.

The highly developed love of decoration of the Bakuba appears in their masks, which are either of a pull-on variety made of hide or woven fibre, or of carved wood. The first kind, which is heavily embroidered with coloured beads and cowries, should really be considered in the near-abstract class, so much does representation give way to decoration. In some the head is surmounted with a curious horn-like arrangement with tusks affixed to its base, which would appear to be suggestive of an elephant's trunk. The general effect of these curious masks is bright and gay. The wooden ones, although far more naturalistic, are also covered in fine geometric pattern-work in several colours, such as white, black and yellow (PLATE XLII, B).

The carved wooden cups and goblets of the district are of very great artistic value. Some are in the form of a hollow human head supported on a pedestal-like neck. These heads are extremely naturalistic and individual, so much so that it must be assumed that they are carved from actual models. They have none of the grotesqueness of the pipes of the Cameroons, and their interest lies in the successful combination of naturalism and three-dimensional design (PLATE II, B).

The Ben-lulua, who are neighbours of the Bakuba, carve ancestor figures which have great ornamental value. Although fairly static in pose, the figures are sometimes represented as holding objects in their hands, and show a lively feeling in spite of their rigidity. Well polished, both body and face are covered with fine cicatrices, so that the whole carving is a mass of pattern (PLATE XLIV, A and B).

The Dengese, who are also in the Bakuba area, carve large ancestor figures which are simple and static in form, but in which the whole torso is covered with a finely incised whitened rhomboid pattern (PLATE XLIV, c).

<div align="center">

THE BALUBA

(The Baluba and Basonge, Balunda and Batshioko tribes)

</div>

Two motifs are very common in Baluba sculpture; the first is a caryatid figure supporting a stool or sometimes a head-rest; the second a female figure holding a bowl.

Of the first, the caryatid form of stool, it is said that the head of every substantial household has a well-carved stool, usually representing a kneeling woman supporting the seat, with open hands at the side of the head. Male figures are known, while sometimes a pair of figures, male and female, standing back to back, or beside one another, are carved.

It would seem that these caryatid figures, as well as other figure carving of the Baluba, consist in the north of very rounded forms; while further south the form tends to be more angular, the body consisting of a long cylinder, with the neck almost as broad as the trunk. The female trunk is almost always heavily cicatrized below the breasts, while both male and female have a very pronounced navel. The balance and solidity required to give a sense of security in a stool are obtained by greatly exaggerating the size of the neck and arms, and rendering the legs insignificant except as a kind of anchor to the base. To do this the legs are made extremely short, the figure appears more to sit upon the base than to kneel, while the lower leg is splayed out and bent back like a frog's. The total height of the stools is between 40–50 cm. The general shape of the head is very rounded with a bulging forehead; in the more angular figures it tends to become pointed towards the chin. The face is fairly naturalistic, and the eyes with their drooping upper lid appear nearly shut. The hair is represented as brushed well back, being bound at the temples by a plaited band. There would appear to be several methods of treating the hair at the back of the head; most commonly it is arranged in the form of a cross, or is cut in a series of flounces very like the papyrus thatching of hut roofs. These caryatid stools, used as they are by the head of every substantial household, suggest a people for whom beautiful craftsmanship is an essential part of life.

In the figures of women carrying bowls the exact purpose of the carv-

ing is not known, although various suggestions have been made by Maes and others. They are often called Kabila figures — Kabila apparently being the name of a goddess — but beyond the fact that they play a part in certain rituals and seances of divination, nothing more of them is really known at present.

In these figures the same general characteristics obtain as in the caryatid stools, and here again it is interesting to note how the representation of the limbs is made to serve aesthetic rather than naturalistic ends. In the stools security was suggested by the strong supporting arms and the anchor-like form of the legs. In the bowl figures long straight legs often stretch beneath the bowl, or in other cases the figure or figures are carved with arms and legs pressed tightly against it so that they act as a handle.

None of the three Baluba pieces illustrated is of the types described above, but they have been chosen as showing the best qualities of Baluba art. The well-finished rounded forms have great beauty and a sense of serenity and poise. Their reproduction on one page is inevitably misleading, for B is a little carved ivory headrest only some 16 cm. high, while C, a large wooden carving of a pregnant woman, is 90 cm. in height (PLATE XLV).

Mention must be made of the long-faced style of Buli. This consists of some twelve carvings which from their strong unity of style would seem to have come from the hand of one master craftsman, who has been termed 'The Master of Buli'. The only two documented examples were found in the Baluba village of Buli on the Lualaba river. Some of these carvings consist in single caryatid figures supporting stools; and there are also two double caryatid figure stools, one with the figures side by side, the other with the figures back to back. One of the finest is a very beautiful figure of a kneeling woman with a bowl; and two small figures, one male and one female, complete the collection. All are in collections in Europe, at least three of them in the Musée Royale de l'Afrique Centrale, where the late Director, Professor Olbrechts, made a special study of them. It may never be proved that this work is all by one hand, yet certain characteristics which lift it above the work of other craftsmen of the tribe are constant in every piece. With regard to the whole posture, the artist solves his desire to emphasize strength and security, not by enlarging the arms and neck of the caryatid figures as do so many of the Baluba carvers, but by enlarging instead the head and hands. This is a far better solution and allows him to develop the form of the face; very

Hamitic in its features, with its high cheek-bones, raised eyebrows, sharp well-shaped nose, clear-cut mouth and pointed chin. The large flat hands, curving slightly forwards, are far more effective than the lengthened arms; while the treatment of the legs in the kneeling figure is again very different. These figures sit back on the heels, while the legs are long and thin, the lower leg being tucked directly below the thigh. In this work we probably see the African master craftsman beginning to emerge. He is still, unfortunately, anonymous, but we are able to pick him out from the crowd of his contemporaries. Whoever he may have been, in his feeling for rhythm and balance, his sensitivity of line, and delicacy of modelling, he will always stand out among the great sculptors of his race (PLATES XLVI, XLVII).

In the Congo, from a wide area around the Sankuru river, the Benalulua, the Baluba of that district, together with the Bakete, the Batetela and the Basonge, produce masks which, though anthropomorphic in form, are so stylized and decorated as almost to merit the description of near-abstract. These masks are sometimes circular (Baluba) (PLATE XLVIII, E), and sometimes rectangular (Basonge) (PLATE XLVIII, D). The eyes and mouth are carved as strongly protruding geometric forms, while the whole face is covered with a network of finely incised parallel or concentric lines forming a pattern of black and white.

Although the Basonge are closely related to, and near neighbours of, the Baluba, their art has none of the sensitive grace of much of the Baluba work. It consists chiefly of medicine-containing figures, and its great merit lies in the very marked quality of expressing power and strength (PLATE XLVIII, c).

In all this vast stretch of country over-run by the Baluba and Balunda there are, of course, a great many different 'schools' or styles of art. That of the Batshioko is entirely different from the Baluba, showing in its figure carving a streak of brutality and fierceness totally unlike the polished subtlety of the latter. The people are described by Torday as a fierce and warlike tribe, and this characteristic is strongly reflected in their carvings, which have a powerful ferocity (PLATE XLVIII, B).

They also decorate chairs (which must have come from some European prototype) and other objects with figure carving (PLATE XLVIII, A).

Other sub-styles, such as that of the Warega, do not appear to be of sufficient aesthetic merit to be mentioned in a book of this size, which has attempted to pick out only such work of the African primitives as

may be of value to the African artist of the future. In all the work which we have considered we have found characteristics which must claim the respect of every artist. The day of the primitive African artist is passing; in his place will come a man of more developed intellectual gifts and a differing social and religious outlook. But he cannot afford to neglect the past, for the old African artists knew their job and did it with great skill and perception. It is to a great extent through appreciative study of the past that the modern African artist may hope to develop in his turn the undoubted artistic genius of his race.

SELECTED BIBLIOGRAPHY

ALLISON, PHILIP, *African Stone Sculpture*, Lund Humphries, 1968.

DARK, PHILIP, *Benin Art*, London, 1960.

FAGG, W., *African Tribal Images*, Cleveland Museum of Art, 1968.

—— *African Tribal Sculptures*, 2 vols., Methuen, 1966.

—— *Tribes and Forms in African Art*, Methuen, 1966.

FAGG and ELISOFON, *The Sculpture of Africa*, London, 1958.

FAGG and LIST, *Nigerian Images*, London, 1963.

FAGG, W. and PLASS, M., *African Sculpture*, Studio Vista, Ltd., London, 1964.

GRIAULE, M., *Arts of the African Native*, London, 1950.

KJERSMEIER, C., *Centres de Style de la Sculpture Negre Africaine*. (4 vols.) Paris and Copenhagen.

LEM, F. H., *Sudanese Sculpture*, Paris, 1948.

LEUZINGER, ELSY, *Africa: The Art of the Negro Peoples*, Arts of the World, Vol. 3, pp. 247. Methuen, London, 1960.

PAULME-SCHAEFFNER, D., *African Sculpture*, Trans. Michael Ross, London, 1962.

TORDAY and JOYCE, *Les Bushongo*, Teruven, 1913.

TROWELL, M. and HANS NEVERMANN, *African and Oceanic Art*, Abrams, New York, 1968.

UNDERWOOD, L., *Figures in Wood of West Africa*, Tiranti, 1948.

—— *Masks of West Africa*, Tiranti, 1948.

—— *Bronzes of West Africa*, Tiranti, 1949.

INDEX

INDEX

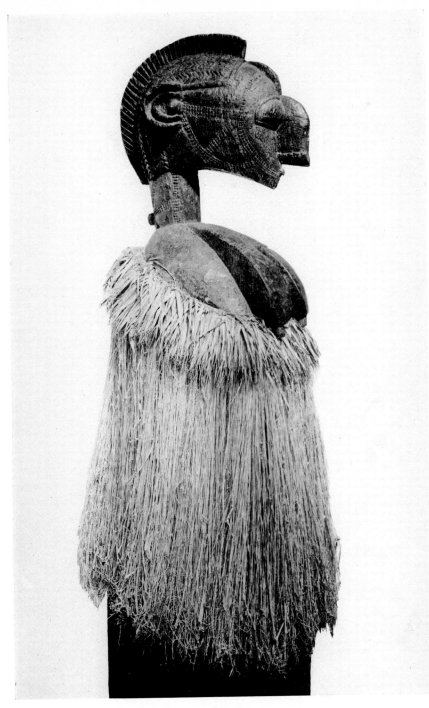

Plate I
SCULPTURE OF THE SPIRIT-REGARDING ORDER
Nimba mask. Wood. Baga, Guinea. *British Museum*

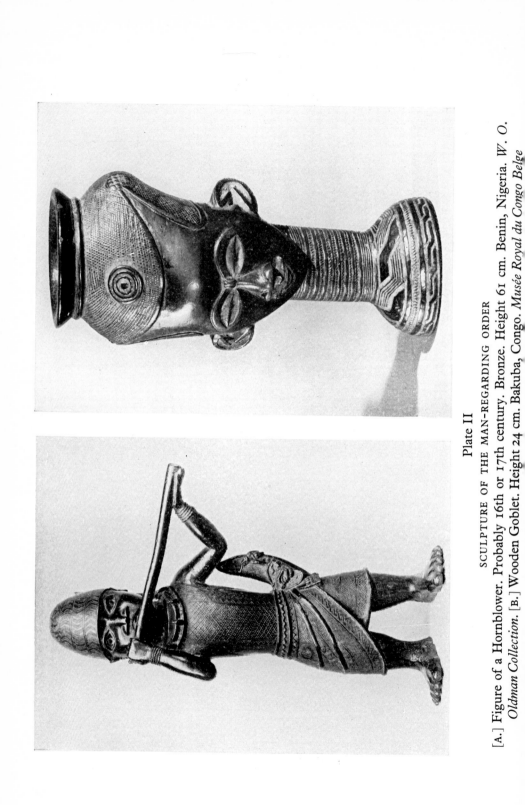

Plate II

SCULPTURE OF THE MAN-REGARDING ORDER

[A.] Figure of a Hornblower. Probably 16th or 17th century. Bronze. Height 61 cm. Benin, Nigeria. *W. O. Oldman Collection.* [B.] Wooden Goblet. Height 24 cm. Bakuba, Congo. *Musée Royal du Congo Belge*

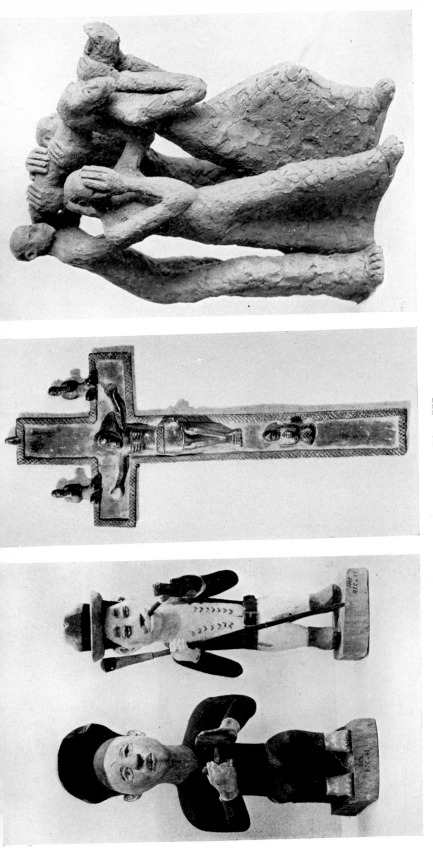

Plate III

SCULPTURE SHOWING EUROPEAN OR CHRISTIAN INFLUENCE

[A.] Carvings of Europeans. Wood. Congo. *Musée Royal du Congo Belge.* [B.] Crucifix in brass. 32 cm. Lower Congo. 17th–18th century. *Musée Royal du Congo Belge.* [C.] 'The Burial of Christ.' Terra cotta. 45 cm. By R. Namuli. The Margaret Trowell School of Art. Makerere University College. 1952. *Margaret Trowell Collection*

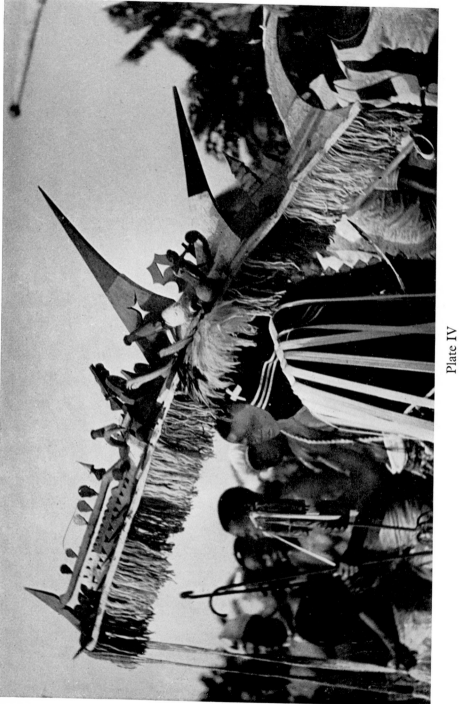

Plate IV

THE MASK AS AN OBJECT OF RITUAL DISPLAY

Masked dancer. Abua tribe of the Lower Orashi River. Nigeria. *Photograph: G. I. Jones*

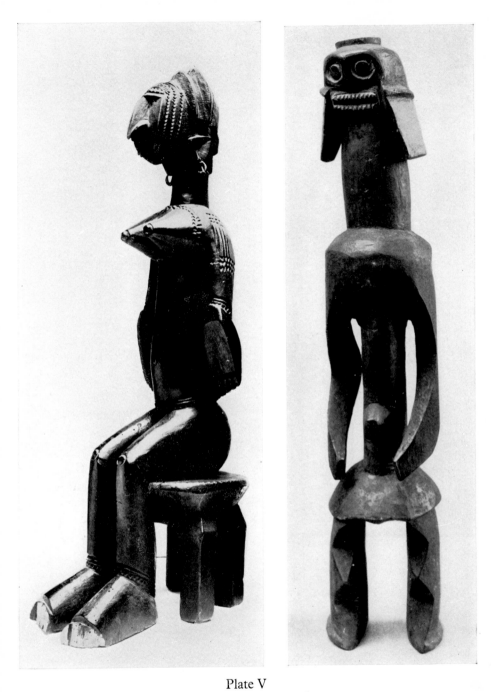

Plate V

CARVING OF THE WESTERN SUDAN

[A.] Ancestor figure. Wood. Height 60 cm. Bambara, Mali. *British Museum.*
[B.] Ancestor figure. Wood. Probably Chamba, Northern Nigeria

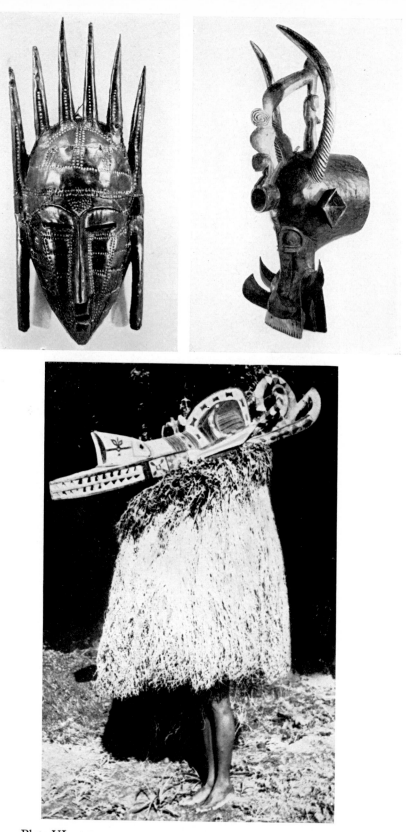

Plate VI MASKS OF THE SENUFO, AND MASKED DANCER
[A.] Wooden mask covered with metal. Senufo. *Musée de l'Homme.*
[B.] Zoomorphic mask. Wood. Senufo. *Musée de l'Homme.*
[C.] Masked dancer. Nalou. I.F.A.N. *Photograph: Labitte*

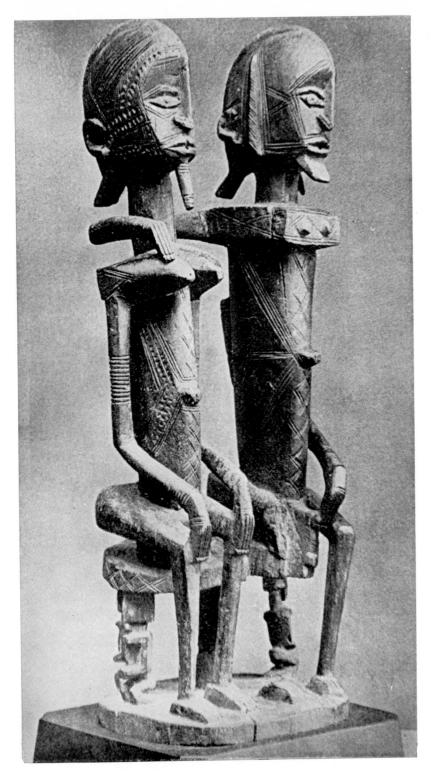

Plate VII
CARVING OF THE DOGON. MALI
Ancestor figures. Wood. Height 75 cm. *Barnes Foundation. Merion, Pennsylvania*

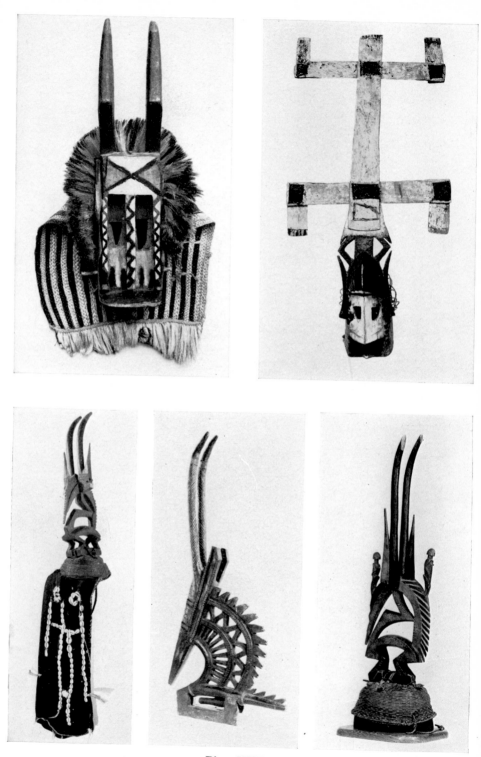

Plate VIII

MASKS OF THE DOGON AND BAMBARA CRESTS. MALI

[A.] Mask. Wood. Dogon. *British Museum.* [B.] Mask. Wood.
Dogon. *British Museum.* [C.] Headdress. Wood. Bambara. *Musée de l'Homme.*
[D.] Headdress. Wood. Bambara. *Musée de l'Homme.* [E.] Mask. Wood. Bambara.
British Museum

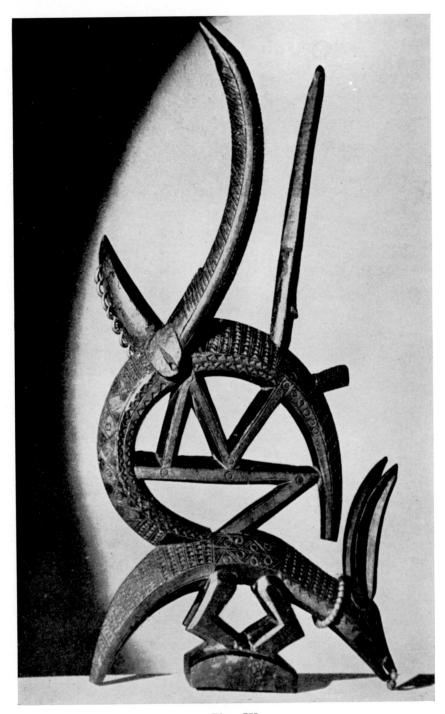

Plate IX
CREST OF BAMBARA HEADDRESS. MALI
Wood. Height 41 cm. *Carl Kjersmeier Collection*

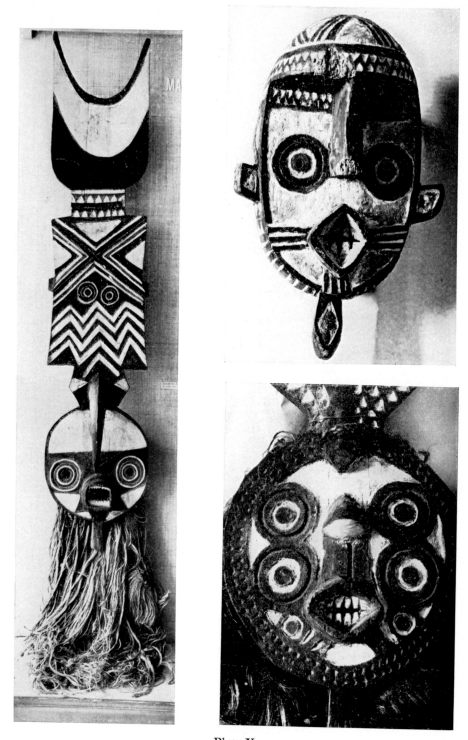

Plate X
MASKS OF THE BOBO. MALI
[A.] Carved and painted wood. Height 175 cm. *Musée de l'Homme.*
[B.] Carved and painted wood. Height 62 cm. *Musée de l'Homme.*
[C.] Carved and painted wood. Detail of tall mask as [A.]. *Musée de l'Homme*

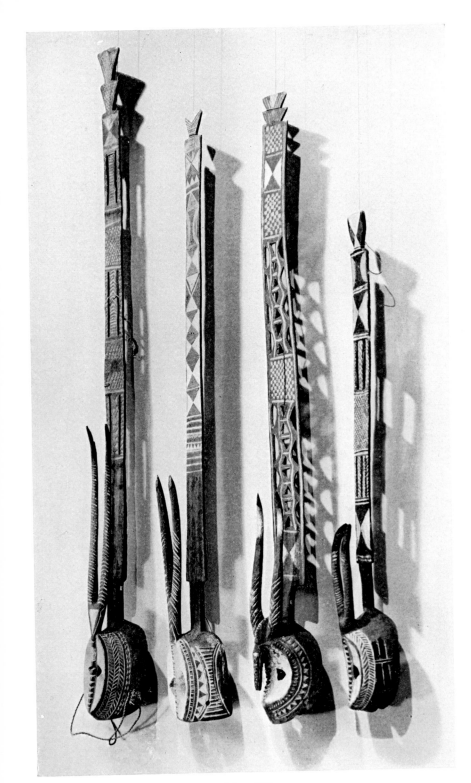

Plate XI
MASKS OF THE MOSSI, WESTERN SUDAN
Wood, polychrome. Height between 160 and 218 cm. *Helena Rubinstein
Collection, Paris*

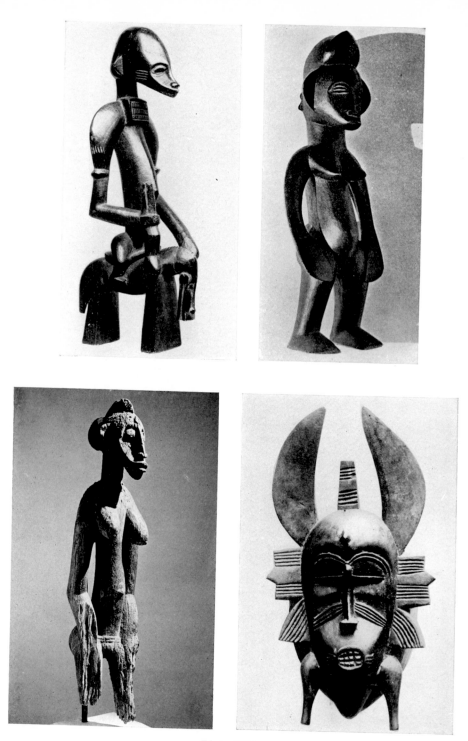

Plate XII
FIGURES AND MASK. SENUFO. IVORY COAST
[A.] Figure of a horseman. Wood. *British Museum.* [B.] Ancestor figure. Wood.
Height 19 cm. *Carl Kjersmeier Collection.* [C.] Figure used at dances. Wood. 95 cm.
Rietberg Museum, Zürich. [D.] Mask. Wood. Height 36 cm. *Musée de l'Homme*

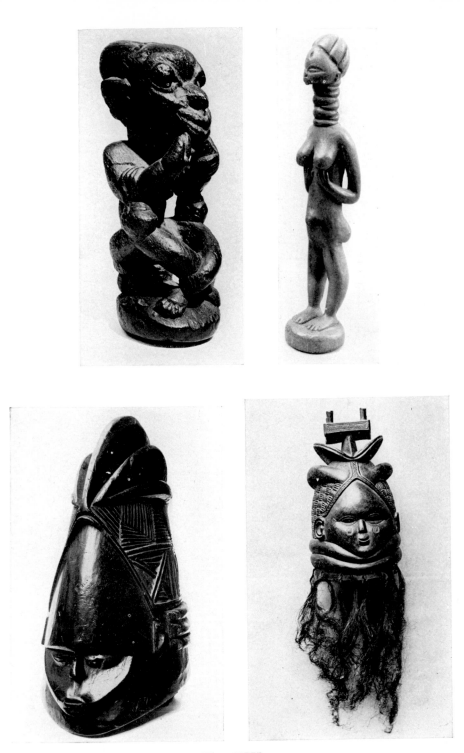

Plate XIII

FIGURE CARVING AND MASKS. MENDE. SIERRA LEONE

[A.] Ancient soapstone carving. 'Nomoli'. Height 20 cm. *R. J. Sainsbury Collection, London. Photograph: Victoria & Albert Museum.* [B.] Modern carving in wood. 'Minsereh'. *Cambridge University Museum of Archaeology and Ethnology.* [C.] Bundu mask. Blackened wood. *Plass Collection. British Museum.* [D.] Bundu mask. Blackened wood. Height about 46 cm. *British Museum*

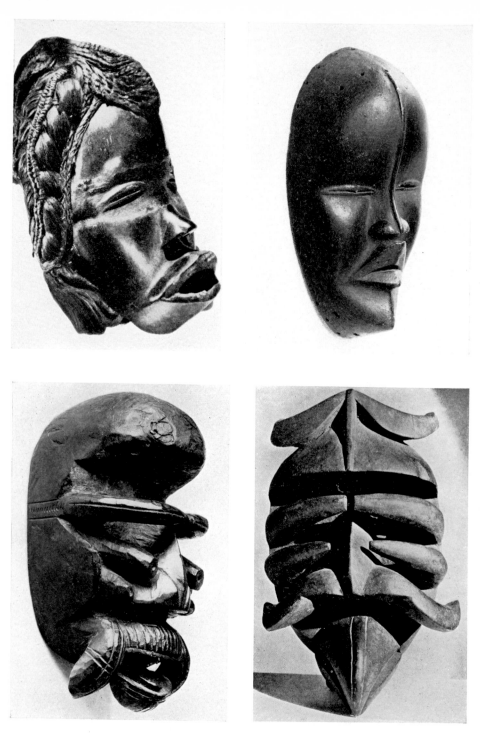

Plate XIV

PORO MASKS OF THE DAN-NGERE TRIBES

[A.] Naturalistic mask. Wood. Height 36 cm. *Late Miré Collection, Paris.* [B.]
Naturalistic mask. Wood. Height 22 cm. *Royal Scottish Museum, Edinburgh.*
[C.] Highly stylised mask. Wood. Height 27 cm. *Plass Collection. British Museum.*
[D.] Highly stylised mask. Wood. Height 32 cm. *Carl Kjersmeier Collection*

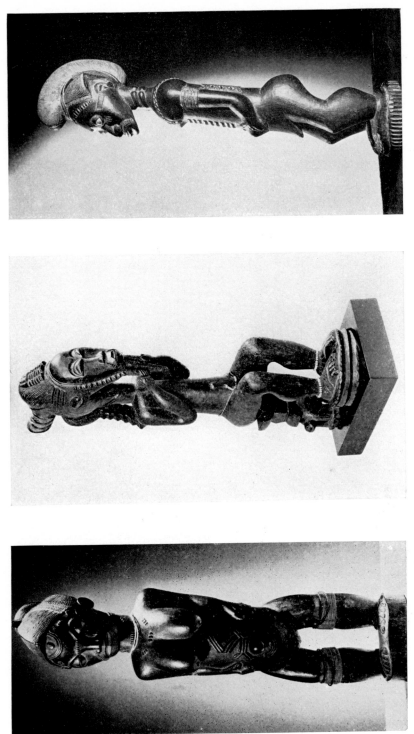

Plate XV

FIGURE CARVING OF THE BAULE. IVORY COAST

[A.] Female figure. Wood. Height 47 cm. *Carl Kjersmeier Collection.* [B.] Seated male figure. Wood. Height 47 cm. *Royal Scottish Museum, Edinburgh.* [C.] Male figure. Wood. Height 44 cm. *Carl Kjersmeier Collection*

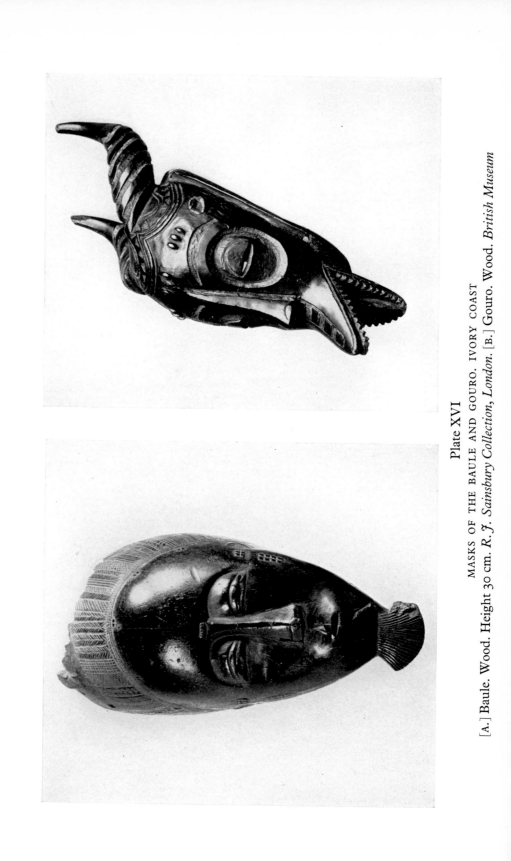

Plate XVI

MASKS OF THE BAULE AND GOURO. IVORY COAST

[A.] Baule. Wood. Height 30 cm. *R. J. Sainsbury Collection, London.* [B.] Gouro. Wood. *British Museum*

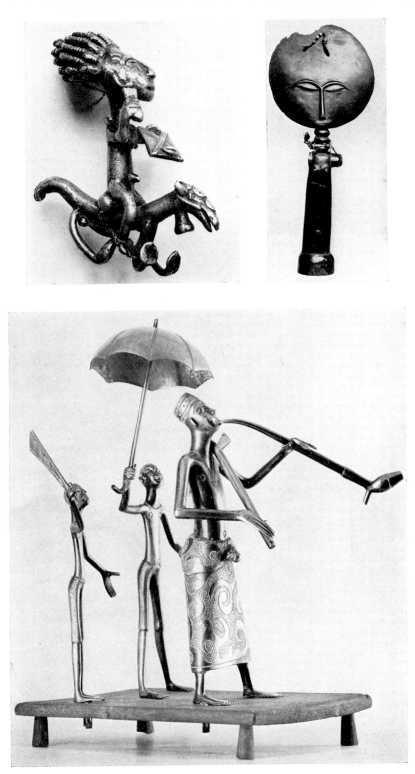

Plate XVII

FIGURE CARVING AND CASTING FROM DAHOMEY AND ASHANTI. GHANA
[A.] Gold weight. Bronze cast. Height 9 cm. Ashanti. *British Museum.* [B.] 'Akua'ba'
figure. Wood. Ashanti. *British Museum.* [C.] Group of chief and his retainers.
Bronze cast. Dahomey

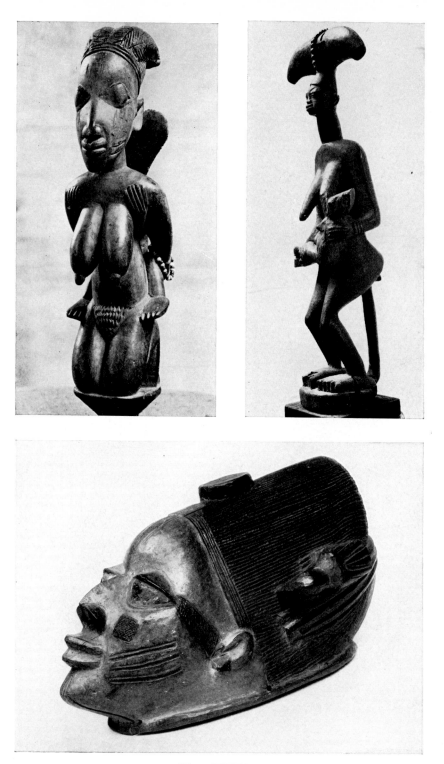

Plate XVIII

FIGURE CARVINGS AND MASK. YORUBA. NIGERIA

[A.] Top of Shongo priest's staff. Wood. Height 37 cm. Ekiti style. *René d'Harnoncourt Collection, N.Y.* [B.] Carving of woman and child. Wood. Height 42 cm. Ekiti style. *Late Collection, Leon Underwood, London.* [C.] 'Gelede' mask. Wood. *British Museum*

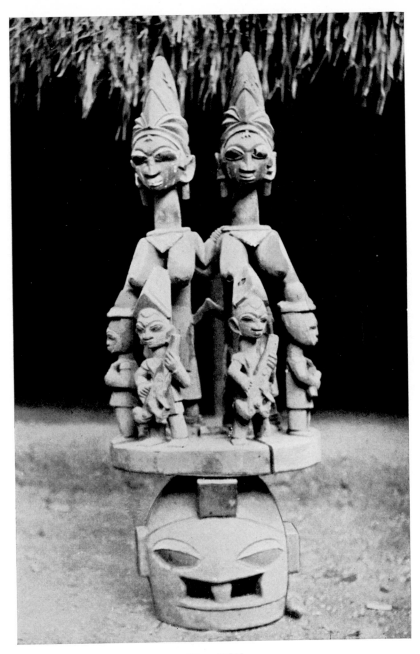

Plate XIX
YORUBA MASK. NIGERIA
'Epa' mask, by the carver Bamgboye of Odo-owa. Wood. Height 100 cm.
Ekiti style. *British Museum*

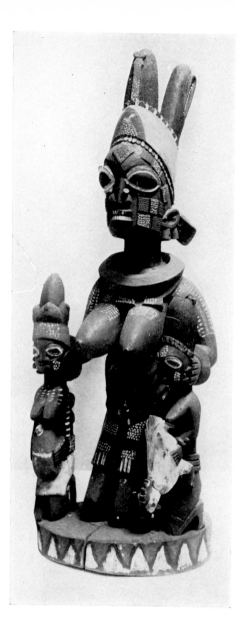

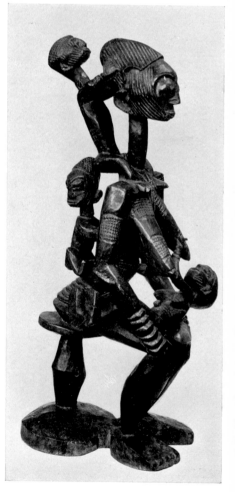

[A.] Wood, coloured in polychrome.
Height about 110 cm. Ekiti style.
British Museum

[B.] Hard wood, painted black. Height 60 cm.
Afo style. *Horniman Museum, by permission of
the London County Council*

Plate XX
REPRESENTATIONS OF ODUDUA. NIGERIA

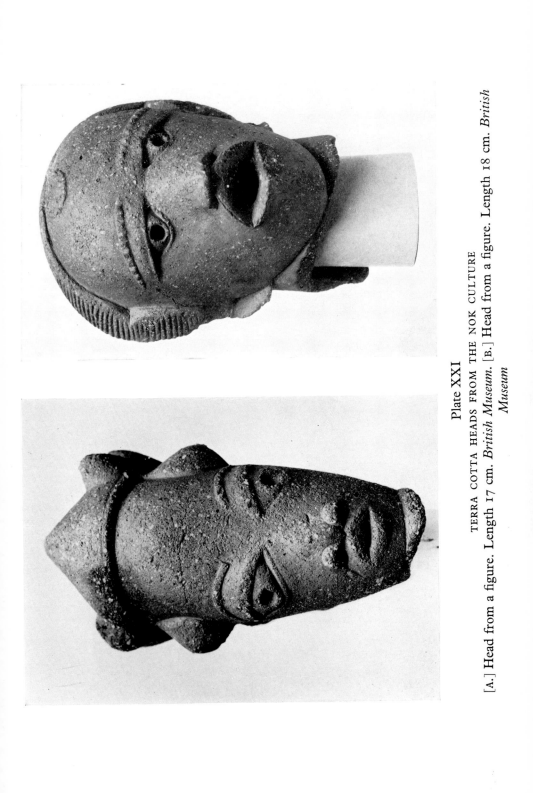

Plate XXI

TERRA COTTA HEADS FROM THE NOK CULTURE

[A.] Head from a figure. Length 17 cm. *British Museum.* [B.] Head from a figure. Length 18 cm. *British Museum*

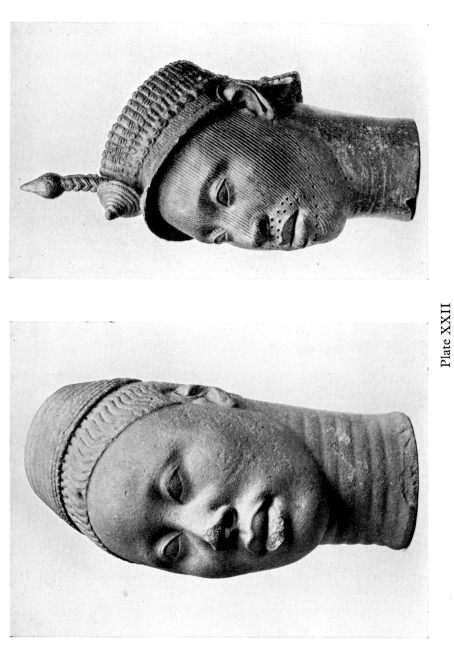

Plate XXII

BRONZE AND TERRA COTTA HEADS FROM IFE. NIGERIA

[A.] Head of Lajuwa. Possibly 13th century. Life size. *Oni of Ife Collection.* [B.] Slightly under life size.

British Museum

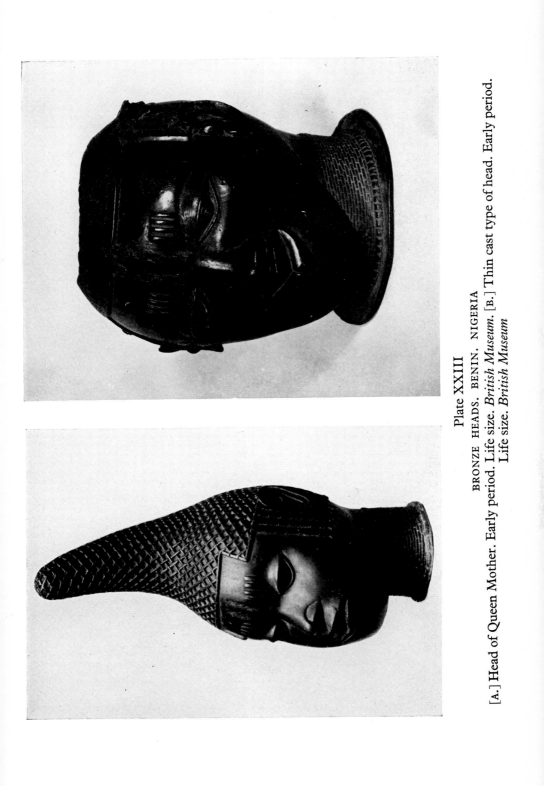

Plate XXIII

BRONZE HEADS. BENIN. NIGERIA

[A.] Head of Queen Mother. Early period. Life size. *British Museum.* [B.] Thin cast type of head. Early period.
Life size. *British Museum*

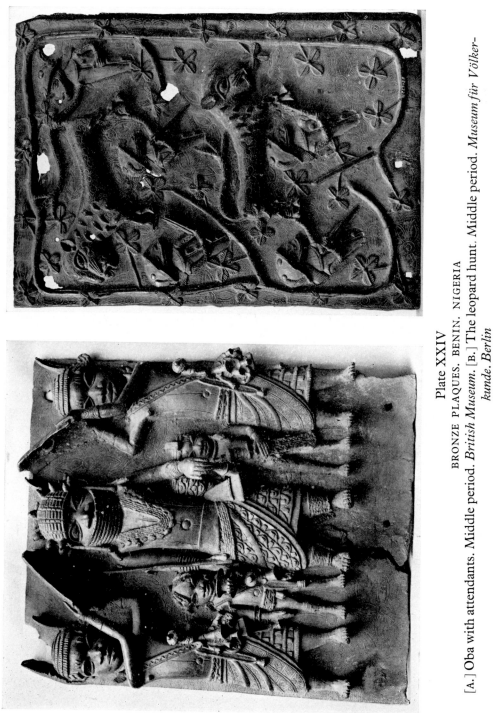

Plate XXIV

BRONZE PLAQUES. BENIN. NIGERIA

[A.] Oba with attendants. Middle period. *British Museum.* [B.] The leopard hunt. Middle period. *Museum für Völker-kunde. Berlin*

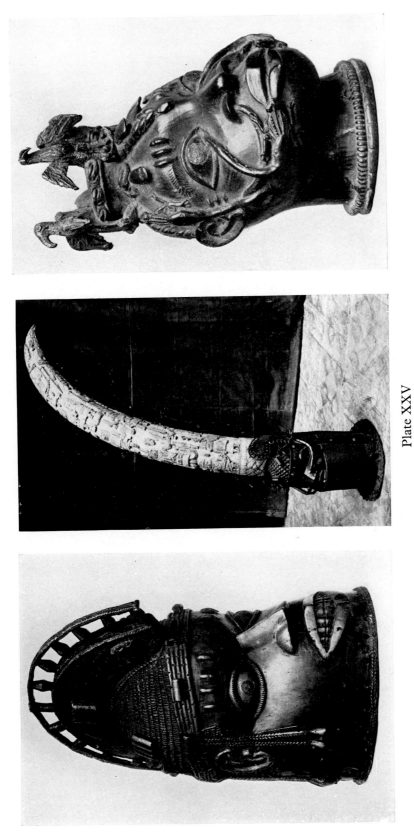

Plate XXV

BRONZE HEADS. BENIN. NIGERIA

[A.] Crested head. Probably late period. Height 27 cm. *British Museum.* [B.] Heavy head supporting tusk. Late period. Height 51 cm. *British Museum.* [C.] Head possibly belonging to a spirit cult. Late period. Height 26 cm. *British Museum*

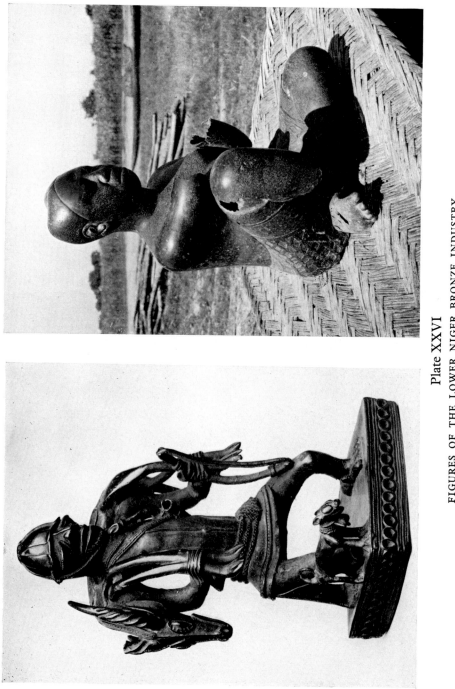

Plate XXVI

FIGURES OF THE LOWER NIGER BRONZE INDUSTRY

[A.] The hunter. Height 37 cm. *British Museum.* [B.] Seated figure. Tada. Height 55 cm. *Photograph: William Fagg*

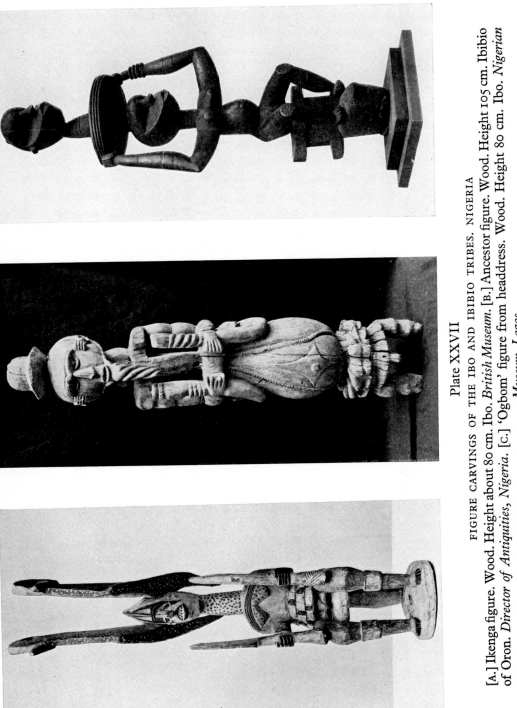

Plate XXVII

FIGURE CARVINGS OF THE IBO AND IBIBIO TRIBES. NIGERIA

[A.] Ikenga figure. Wood. Height about 80 cm. Ibo. *British Museum*. [B.] Ancestor figure. Wood. Height 105 cm. Ibibio of Oron. *Director of Antiquities, Nigeria*. [C.] 'Ogbom' figure from headdress. Wood. Height 80 cm. Ibo. *Nigerian Museum, Lagos*

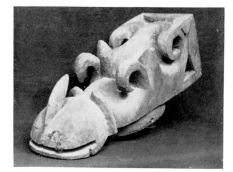

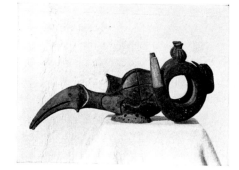

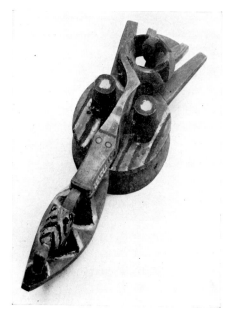

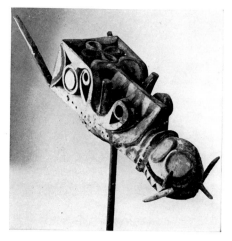

Plate XXVIII

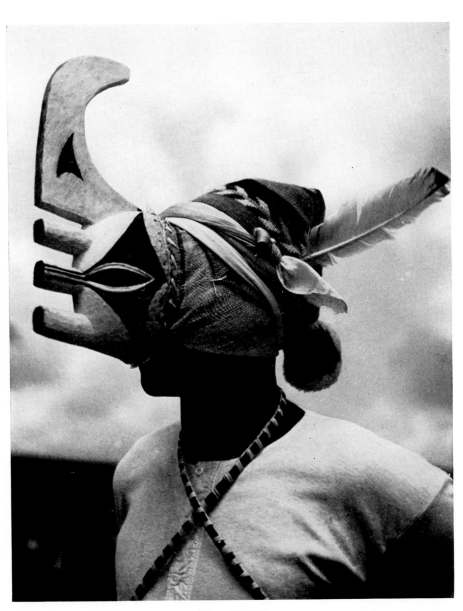

Plate XXIX
IBO MASK. NIGERIA
Ogu or *Maji* mask used in *Iko Okochi* festival. Wood. Afikpo District. Ogoja
Province. *Photograph: G. I. Jones. Cambridge*

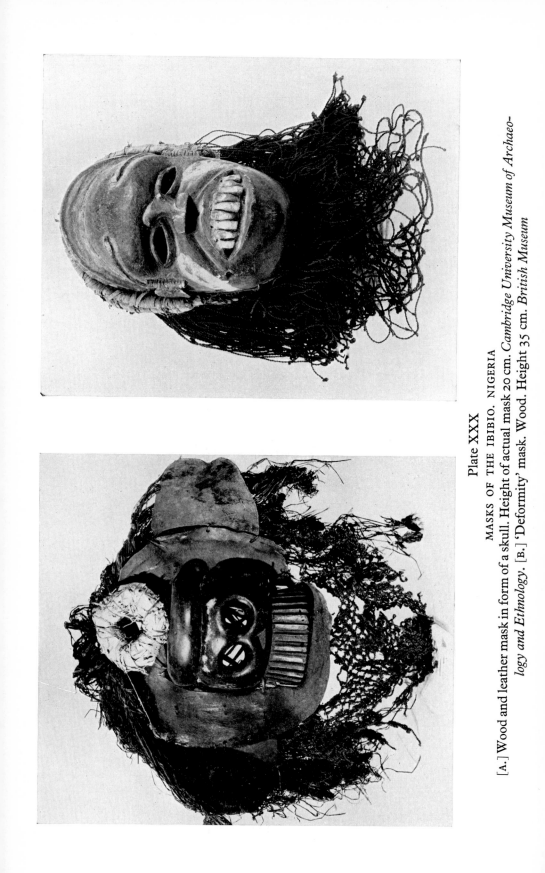

Plate XXX

MASKS OF THE IBIBIO. NIGERIA

[A.] Wood and leather mask in form of a skull. Height of actual mask 20 cm. *Cambridge University Museum of Archaeology and Ethnology.* [B.] 'Deformity' mask. Wood. Height 35 cm. *British Museum*

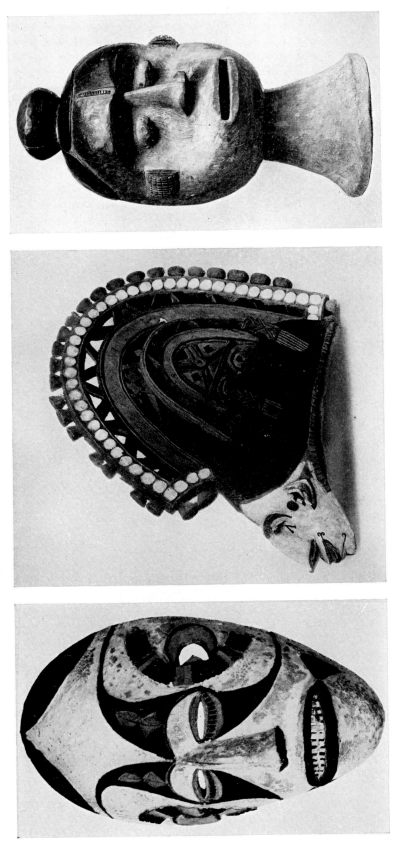

Plate XXXI

IBO MASKS. NIGERIA

[A.] White faced maiden spirit mask of the *Mmo* Society. Wood. Height 19 cm. Onitsha Ibo. *Uganda Museum.*
[B.] Crested *Mmo* mask. Wood. Height about 40 cm. Onitsha Ibo. *British Museum.* [C.] Type used in *Ekpe* play as an
'Elephant Spirit'. Wood. Height about 36 cm. Ibo of Aba and Bende. *British Museum*

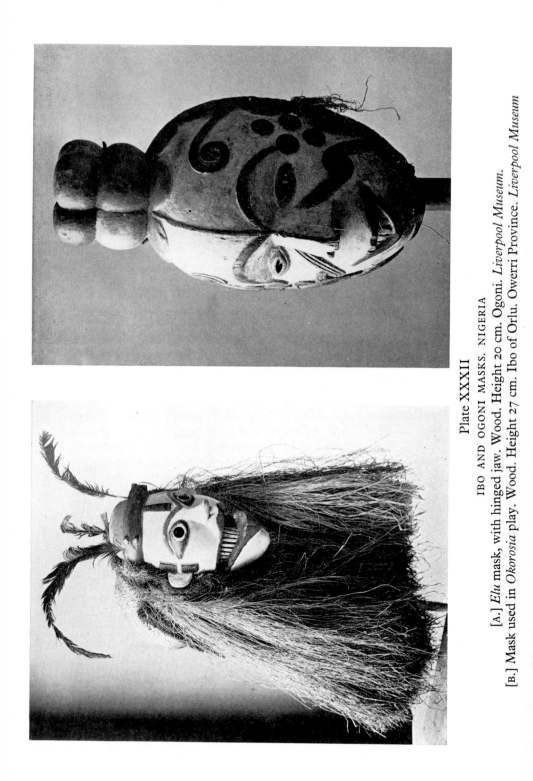

Plate XXXII

IBO AND OGONI MASKS. NIGERIA

[A.] *Elu* mask, with hinged jaw. Wood. Height 20 cm. Ogoni. *Liverpool Museum.*
[B.] Mask used in *Okorosia* play. Wood. Height 27 cm. Ibo of Orlu. Owerri Province. *Liverpool Museum*

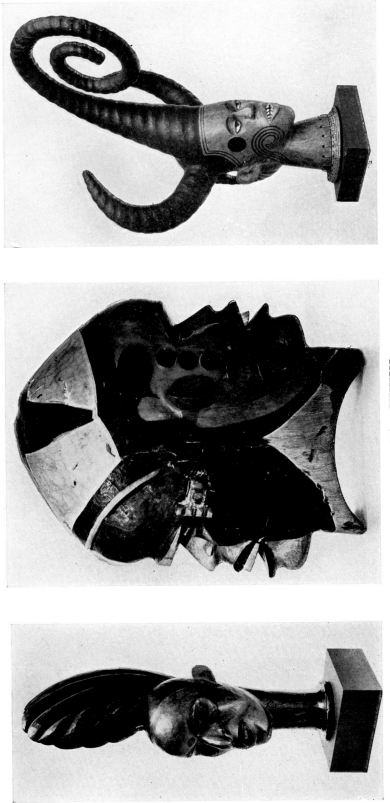

Plate XXXIII

MASKS OF THE CROSS RIVER TRIBES. NIGERIA

[A.] Skin covered head with crest. Height about 45 cm. Probably Ekoi tribe. *British Museum.* [B.] Janus-headed mask. Height about 42 cm. *Cambridge University Museum of Archaeology and Ethnology.* [C.] Skin covered head with horns. *British Museum*

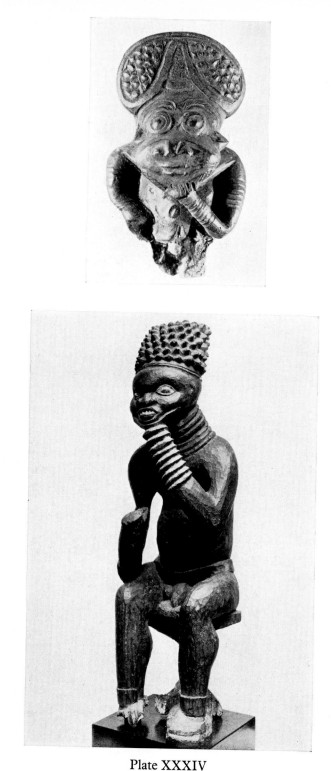

Plate XXXIV
FIGURE CARVING AND PIPE. CAMEROON GRASSLANDS
[A.] Terra cotta pipe. Bamileke. Height 9 cm. *Musée de l'Homme.* [B.] Figure in
wood. Height 99 cm. *Charles Ratton Collection, Paris*

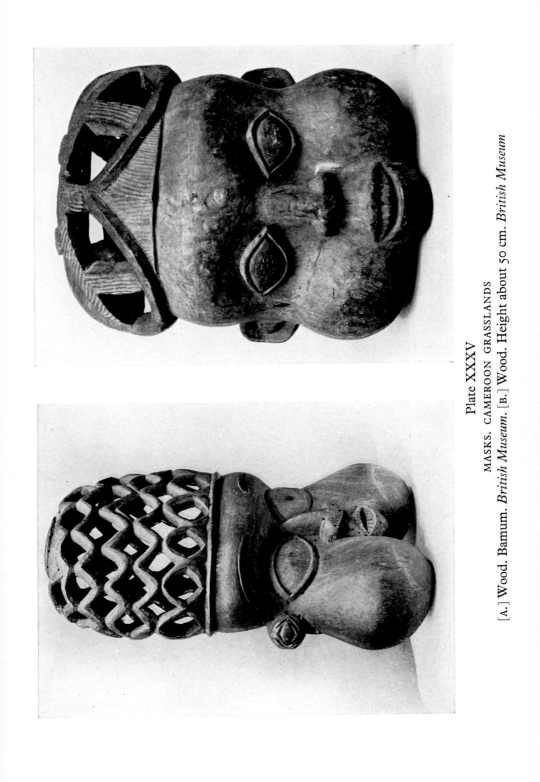

Plate XXXV

MASKS. CAMEROON GRASSLANDS

[A.] Wood. Bamum. *British Museum.* [B.] Wood. Height about 50 cm. *British Museum*

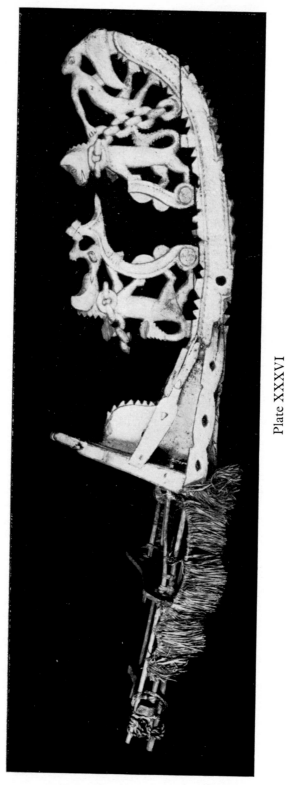

Plate XXXVI

CARVING OF THE DUALA. SOUTHERN CAMEROONS
Canoe prow. Wood. Height 26 cm. Length 220 cm. *Musée de l'Homme*

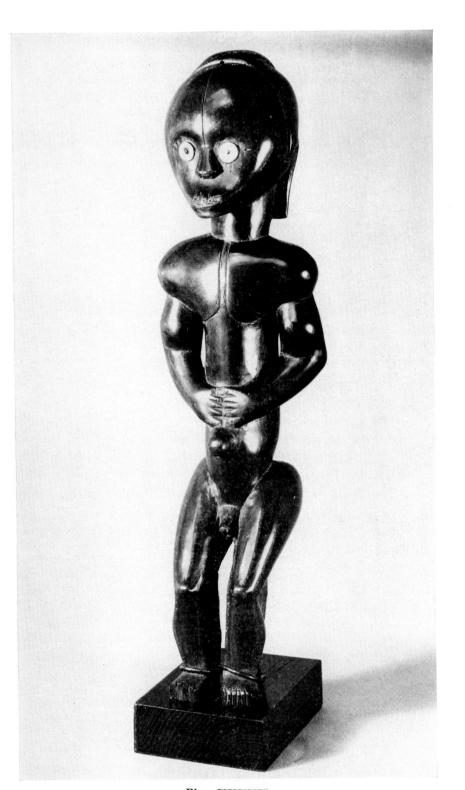

Plate XXXVII

RELIQUARY FIGURE. FANG, GABON
Wood. *British Museum, Plass Collection*

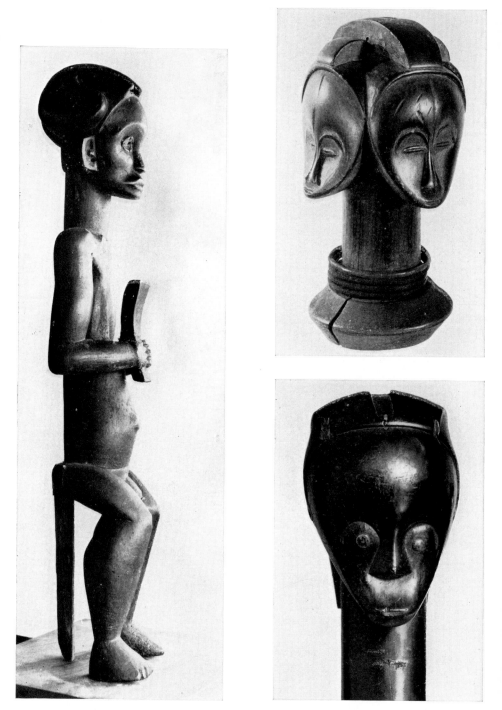

Plate XXXVIII
CARVINGS OF THE FANG. GABON
[A.] Wooden figure. Height 60 cm. *Blair Hughes-Stanton Collection.* [B.] Burial carving. Wood. *Musée de l'Homme.* [C.] Carving of head. Wood. *R. J. Sainsbury Collection, London*

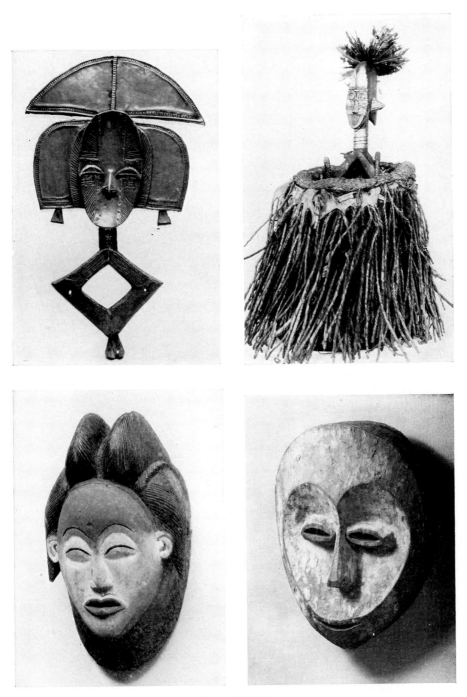

Plate XXXIX

'GUARDIANS OF THE BONES,' BAKOTA; AND MASKS, MPONGWE. GABON

[A.] Guardian figure, wood with applied metal. Bakota. *Plass Collection. British Museum.* [B.] Guardian figure affixed to basket containing bones. Wood with applied metal. Bakota. *Musée de l'Homme.* [C.] White faced mask. Wood. Mpongwe. *British Museum.* [D.] Heart-shaped mask. Bakwele. *British Museum*

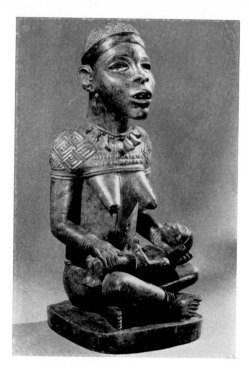

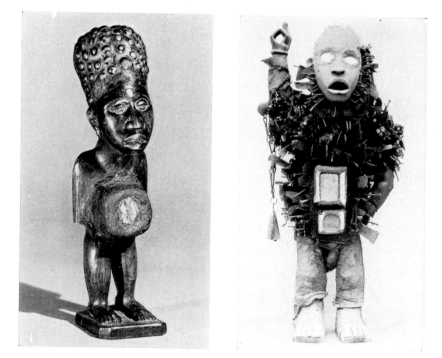

Plate XL

CARVING OF THE LOWER CONGO AREA. CONGO

[A.] Mother and child. Wood. Height 29 cm. Mayombe. *Musée Royal du Congo Belge*. [B.] 'Medicine-containing' figure. Wood with cowrie shell closing cavity in stomach. Height 25 cm. *Musée Royal du Congo Belge*. [C.] 'Medicine-containing' figure. Wood with fragments of mirror closing cavities in stomach. Studded with nails and pieces of metal. Height 83 cm. ?Mayombe.

Musée Royal du Congo Belge

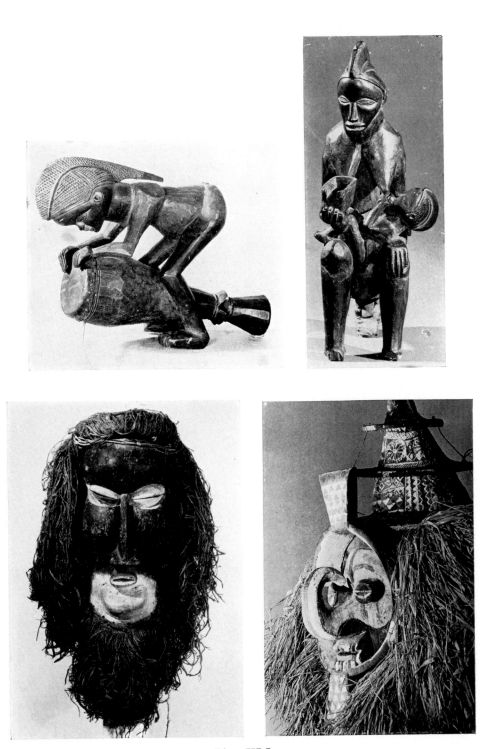

Plate XLI

BAMBALA CARVINGS AND BAYAKA MASKS. KWANGO-KWILU AREA. CONGO

[A.] Drummer. Wood. Height 25 cm. Bambala. *Musée Royal du Congo Belge.*
[B.] Mother and child. Wood. Height 54 cm. Bambala. *Musée Royal du Congo Belge.* [C.] Mask of Chief of Circumcision Rites. Height 90 cm. Bayaka. *Musée Royal du Congo Belge.* [D.] Polychrome mask. Wood. Bayaka. *Musée Royal du Congo Belge*

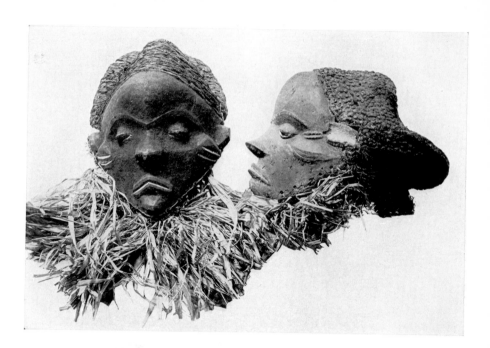

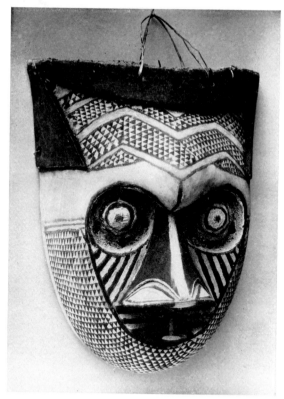

Plate XLII
MASKS OF THE BAPENDE AND BAKUBA. CONGO
[A.] Two masks. Wood. *British Museum*. Bapende.
[B.] Polychrome mask. Bakuba

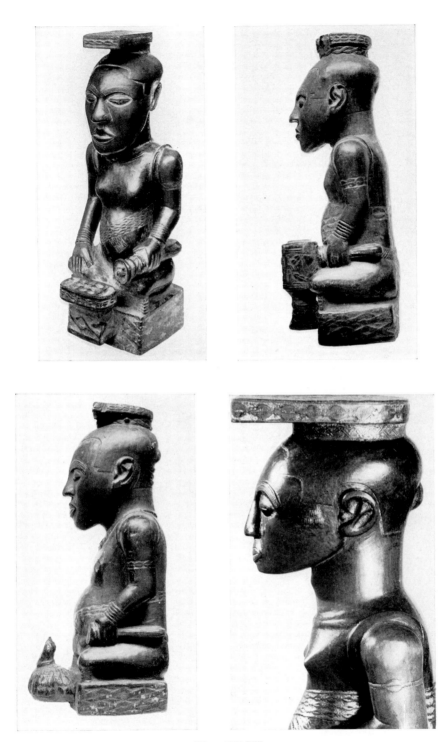

Plate XLIII

STATUES OF THE BAKUBA KINGS. CONGO

[A.] Statue of Shamba Bolongongo. Wood. Height 60 cm. *British Museum*. [B.] Statue of Misha Pelenge. Wood. *British Museum*. [C.] Statue of Bope Pelenge. Wood. *British Museum*. [D.] Statue of Bope Kena. Wood. Height 55 cm. *Musée Royal du Congo Belge*

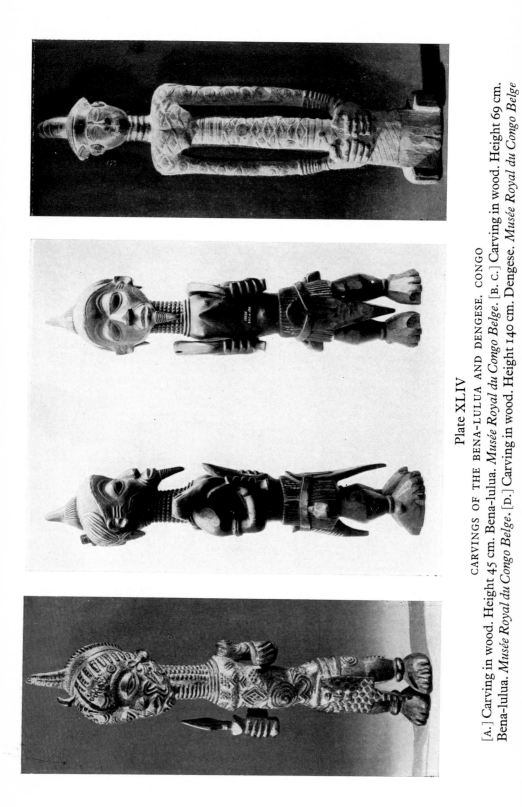

Plate XLIV

CARVINGS OF THE BENA-LULUA AND DENGESE. CONGO

[A.] Carving in wood. Height 45 cm. Bena-lulua. *Musée Royal du Congo Belge.* [B. C.] Carving in wood. Height 69 cm. Bena-lulua. *Musée Royal du Congo Belge.* [D.] Carving in wood. Height 140 cm. Dengese. *Musée Royal du Congo Belge*

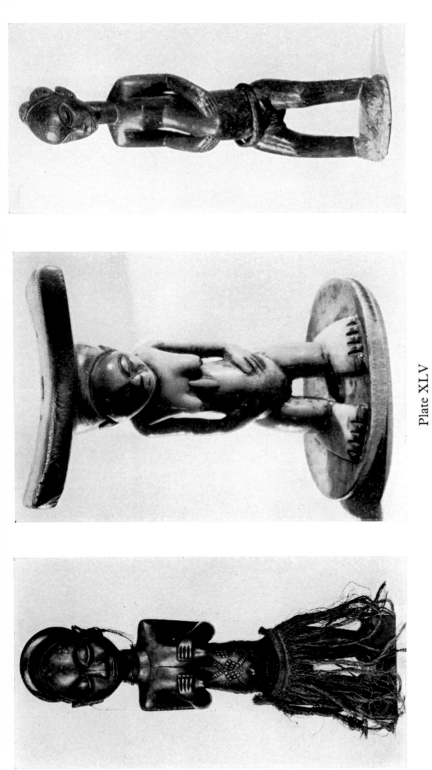

Plate XLV

FIGURE CARVING. BALUBA. CONGO

[A.] Figure in wood. Central style. *British Museum.* [B.] Ivory headrest. Height 16 cm. Wazimba or Batshioko. *Charles Ratton Collection, Paris.* [C.] Ancestor figure. Wood. Height 90 cm. *Musée Royal du Congo Belge*

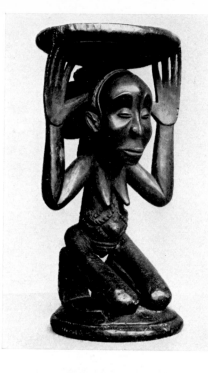

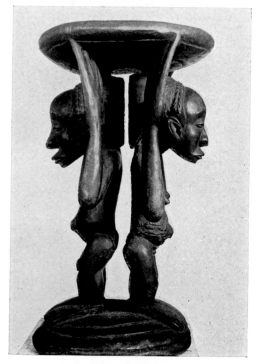

Plate XLVI

LONG-FACED STYLE OF BULI. BALUBA. CONGO

[A.] Caryatid stool. Wood. Height 53 cm. *British Museum*. [B.] Caryatid stool. Wood.
Landesmuseum, Darmstadt

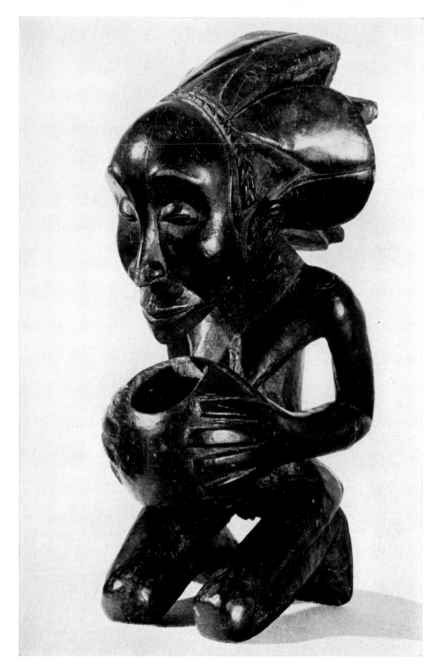

Plate XLVII
LONG-FACED STYLE OF BULI. BALUBA. CONGO
Kneeling woman with bowl. Wood. Height 48 cm. *Musée Royal du Congo Belge*

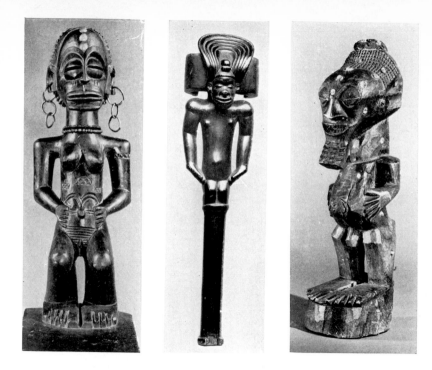

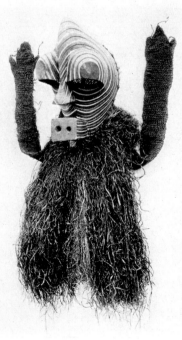

Plate XLVIII

CARVINGS OF THE BATSHIOKO AND BASONGE, MASKS OF THE BASONGE
AND BALUBA. CONGO

[A.] Figure from back of Chief's stool. Wood. Height 34 cm. Batshioko. *Musée Royal du Congo Belge*. [B.] Figure. Wood. Height about 38 cm. Batshioko. *British Museum.* [C.] Figure. Wood. Height 42 cm. Basonge. *Musée Royal du Congo Belge.* [D.] Mask. Wood. Height 55 cm. Basonge. *Musée Royal du Congo Belge.* [E.] Mask. Wood. Height 62 cm. Baluba. *Musée Royal du Congo Belge*